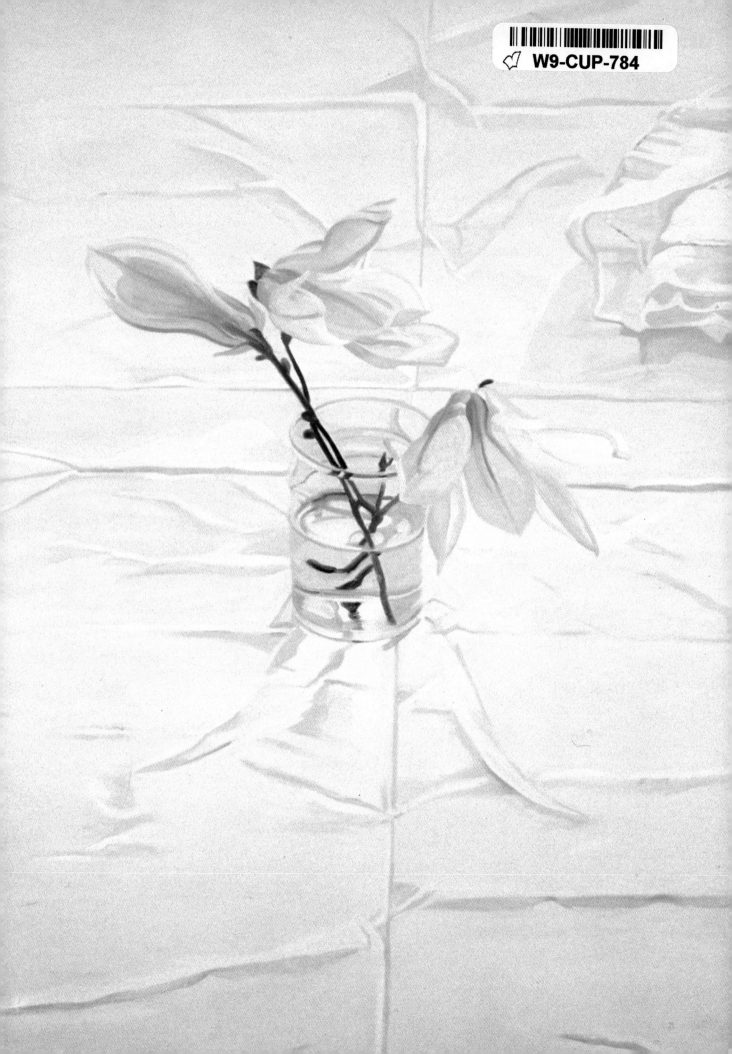

Elizabeth Leonard

PAINTING

FLOWERS

WATSON-GUPTILL PUBLICATIONS
NEW YORK

Front cover art:
Karen Segal,
from **Summer Bouquet Series,**
1981–82, gouache on paper,
10 × 8" (25.4 × 20.3 cm),
photo by David Segal.

Back cover art:
Rose Naftulin,
Summer,
1985, oil on canvas,
44 × 52" (111.8 × 132.1 cm),
photo courtesy of Gross McCleaf
Gallery, Philadelphia.

Art on first page:
Harriet Shorr,
Magnolia,
1976, oil on canvas,
60 × 50" (152.4 × 127 cm),
private collection.

Art on title page:
Elizabeth Osborne,
Spring Flowers,
1985, pastel on paper,
29¾ × 37½" (75.6 × 95.3 cm),
courtesy of Electra Carlin
Gallery, Fort Worth.

Cover design by Bob Fillie, Graphiti Graphics

Edited by Sue Heinemann
Designed by Bob Fillie
Graphic production by Gladys Garcia
Text set in 9-point Palatino

Paperback Edition
First Printing 1991

Copyright © 1986 by Elizabeth Leonard

First published in 1986 by Watson-Guptill Publications,
a division of BPI Communications, Inc.,
1515 Broadway, New York, N.Y. 10036

Library of Congress Catalog Card Number: 86-5527
ISBN 0-8230-3629-4
ISBN 0-8230-3630-8 (pbk.)

Manufactured in Japan

3 4 5 6 / 96 95 94 93

ACKNOWLEDGMENTS
My thanks go first and foremost to the talented artists whose works appear in this book. They made it possible. Bill Scott generously sent many of these artists my way, and I am in his debt. I am also grateful for the help of the Fischbach Gallery in New York City. As always, I appreciate my husband's good humor and unflagging support; without him, I could not have written this book.

I deeply appreciate the efforts of the staff at Watson-Guptill Publications. Senior editor Mary Suffudy started me off and guided me on the way. Designer Bob Fillie is responsible for the book's handsome design, and I am grateful for what he has done. Most of all, I thank, Sue Heinemann, who edited the text. Without her long hours of dedicated and sympathetic work, this book would not have become a reality.

*Karen Segal, **Flower Study**,*
1981–82, colored pencil on paper,
11" × 14" (27.9 × 35.6 cm),
photo by David Segal.

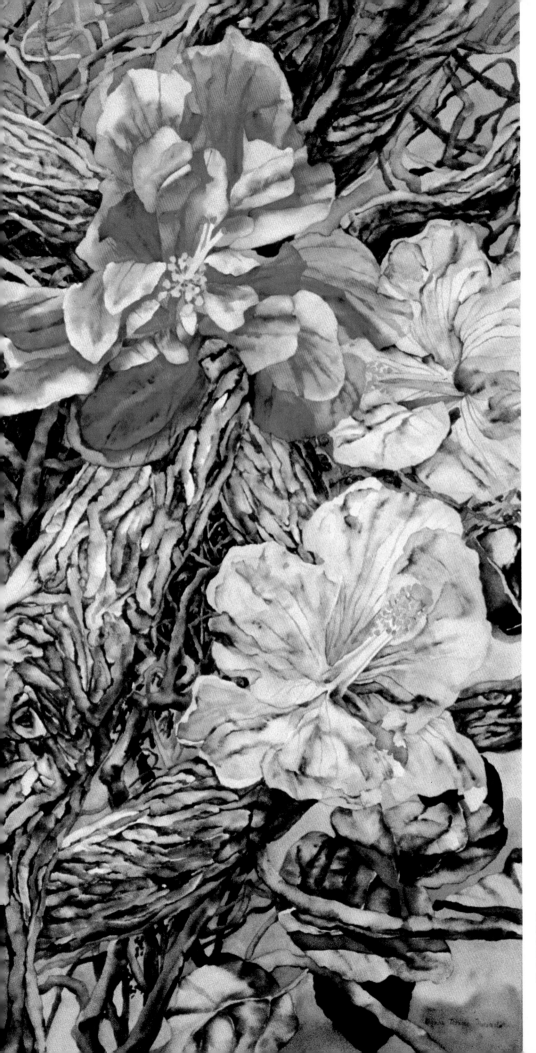

Patricia Tobacco Forrester,
**Honolulu III: Hibiscus
in a Nuuanu Garden,**
*1984, watercolor on paper,
40″ × 51″ (101.6 × 129.5 cm),
private collection.*

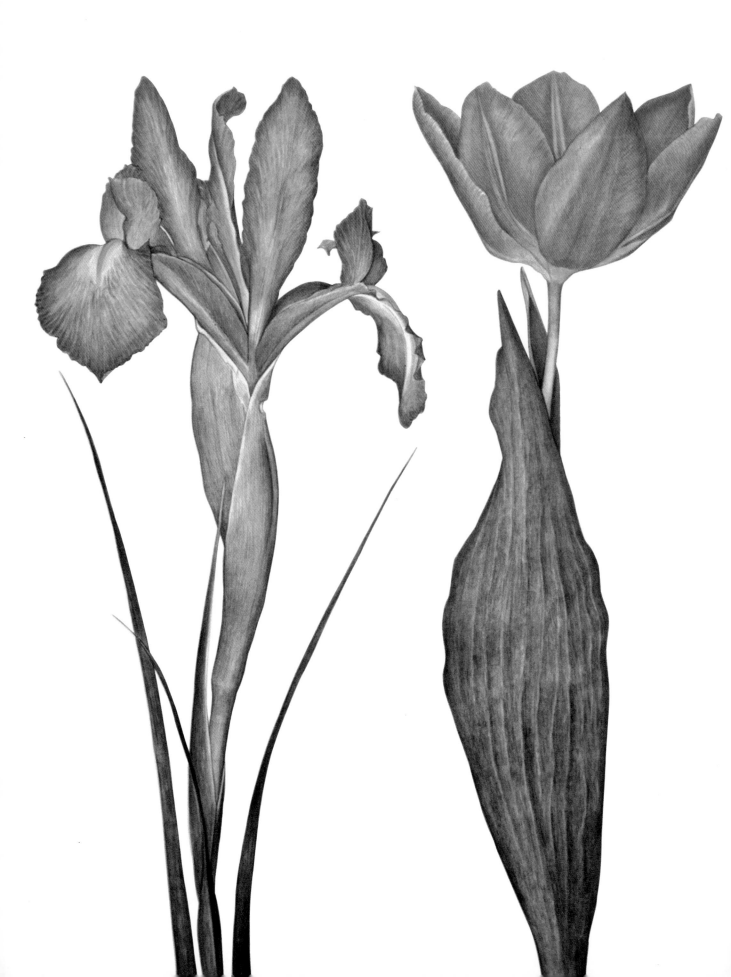

Contents

Pamela Glasscock,
Iris and Tulip,
1984, watercolor on paper,
20" × 16" (50.8 × 40.6 cm),
photo by Tony King.

Introduction

*A*MONG all living things, flowers seem to me the freshest, the sweetest, and the most evocative. The excitement they bring goes, in part, with their ephemeral nature. It is easy to study, understand, and paint things larger and grander—mountains, rivers, and hills, to name just a few. Far more difficult is capturing the life of something that exists for just a few days.

Science has taught us that the beauty of flowers is hardly gratuitous. Were flowers dull green or brown, the insects who help fertilize them would be befuddled, with little notion of where to go or what to do. Attracted by their brilliant hues, bees and other tiny creatures hone in on flowers, help fertilize them, and thus perpetuate some of the most beautiful things in our universe.

Long, long ago—long before history had come to be regarded as history—people celebrated the glorious beauty of flowers. Floral motifs abound in Egyptian art, and Minoan potters freely decorated their wares with lilies and other blossoms. In the Far East, artists approached flowers mystically, seeing them as their neighbors in the universe, and painting them with unsurpassed elegance and grace. A mystical reverence for flowers runs through Renaissance art as well.

Today the impetus may have changed. On the face of it, we are no longer so concerned with eternal truths.

Why, then, do so many gifted artists turn to flowers for their inspiration?

I hold that, in a way, time has stood still. In a single blossom one *can* still see the world. Perfection, we may never find in real life. Things move too fast and are too full of tumult. Standing still, though, gazing at one perfect flower—an orchid, a rose, an iris, a petunia, even a clover —we can all understand what perfection may be.

Talking to the artists whose work is featured in this book has convinced me that the lure of flowers hasn't changed much in the last two thousand years. Today, as before, men and women struggle to capture the beauty of flowers. Flowers stir their creativity in the world that so rapidly whirls about them.

Because you are reading this book, you, too, must want to capture the floral wonders all around you. My hope is that you discover the tools you need to unlock that world here.

To give you a thorough background in flower painting, this book begins by exploring basic concepts—the anatomy of flowers, caring for them, the art of flower arranging, drawing flowers, and botanical illustration. It then goes on to present important aspects of color and composition. Throughout, it is illustrated with the work of outstanding artists.

The color principles discussed range from such fundamental concepts as value

and intensity to the complex interactions among colors that make painting flowers so exciting. As you move on to explore composition, you will discover how different formats affect your subject and how to plan the space in your paintings to highlight the flowers you choose.

Still lifes present some of the most stimulating challenges in flower painting. Working through this section, you will become skilled in assembling and arranging objects, and in weaving them together to create dynamic, unified paintings. The many, varied paintings by skilled artists featured here should provide the inspiration and impetus for making your own personal statement using flowers and other objects.

Finally, you will move outdoors and observe how landscape artists render gardens. You will learn how to gather visual information and how to sort out and organize the profusion of color that confronts you. Most important, you will discover different ways of emphasizing whatever it is that attracts you to a particular scene.

Throughout the book, I suggest exercises to help you incorporate what you have learned into your own paintings. Use whatever medium you like best—watercolor, oil, acrylic, gouache, casein, pastel, or colored pencil. The medium doesn't matter. Learning to see the possibilities all about you is the point of this book.

Nancy Hagin,
Silk and China Birds,
1985, acrylic on canvas,
60″ × 60″ (152.4 × 152.4 cm),
collection of the artist.

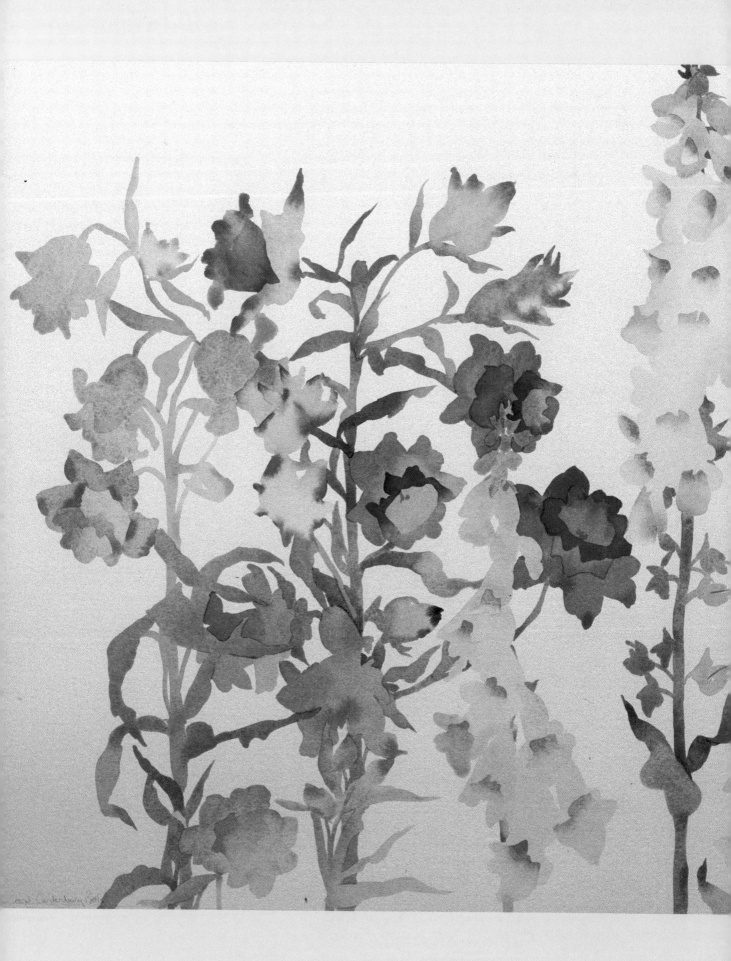

WORKING WITH FLOWERS

FLOWERS SEEM the ideal subject for all levels of painters, from beginners to advanced artists. No other subject gives you so much freedom. Working with flowers, you can control every element in your painting. Select only those flowers that inspire you. Arrange them however you like—in an old jelly glass or in an elaborate porcelain vase. Finally, set up your composition in a way that pleases you, be it simple or ornate.

It isn't just compositional flexibility, though, that draws so many artists to flowers. Flowers have a fresh, hopeful quality that is irresistible. Start drawing and painting flowers and soon you may find yourself delving deeper and deeper into your subject, reading all you can find about flowers, studying their anatomy, and perhaps even growing them for your own use.

Susan Headley Van Campen,
Foxglove and Canterbury Bells,
1985, watercolor on paper,
22" × 30" (55.9 × 76.2 cm),
courtesy of Allport Associates
Gallery, San Francisco.

Studying the Anatomy of Flowers

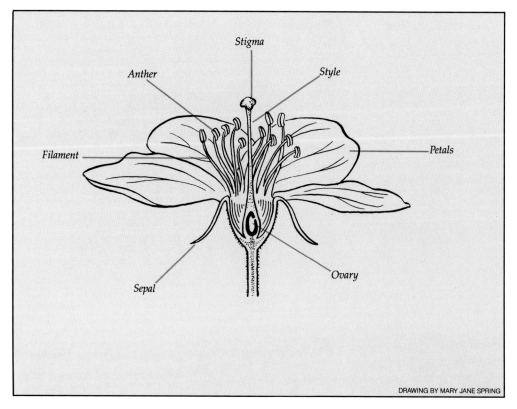

Stigma

Anther

Style

Filament

Petals

Sepal

Ovary

DRAWING BY MARY JANE SPRING

*T*HE MORE you know about the structure of flowers, the more convincing your work will become. Slavish attention to detail isn't the point. If you draw and paint flowers, you want to create an image in which all the elements are logically and organically related. Weak, ambiguous passages rob your work of integrity. If you understand how a snapdragon really looks and how it differs from a daisy, you'll find it much easier to paint flowers, even when you look at them from odd angles.

There is no mystery about how flowers grow. Like all of the other seemingly miraculous wonders of nature, flowers are structured in an easily understood way and are governed by a few simple rules.

BASIC STRUCTURE
All flowers are symmetrical—divided along a midpoint, each side corresponds exactly to its opposite side. Many flowers are radially symmetrical. Their parts, usually petals, radiate out

from one central point, like the spokes on a wheel. These parts are equal, equidistant, and identical to the others in color, size, and shape. Botanists call these radially symmetrical flowers *regular*. Daisies and chrysanthemums are regular flowers.

Irregular flowers are symmetrical, too—bilaterally symmetrical. Unlike regular flowers, which can be divided into three or more equal sections, irregular flowers can be divided along a midline into just two corresponding parts. Orchids are irregular flowers.

Notice, too, as you look at flowers, how they grow on the stem. Some flowers grow singly at the end of a stem or along the length of a stem. Others grow in clusters.

At the top of a flower's stem there are several sepals, which are usually green. Inside the sepals are the individual petals, which are usually colorful and conspicuous. It is inside a flower's petals that the reproductive organs are located.

The female organs are

known as pistils. At the base of the pistil, there is an ovary; inside it are the ovules that will produce seeds. A style rises from the ovary; at the top of the style there is a stigma. When pollen is deposited on the stigma, fertilization can occur.

The male parts are known as stamens. Each stamen has a stalklike portion, called a filament; on top of each filament there is an anther. It is the anther that bears the pollen that will fertilize the seeds.

LEAVES
Leaves are an essential key to plant identification, and they are just as important for the artist who depicts flowers. They grow in distinctive ways and their contours differ from plant to plant. Even their texture matters: some are smooth, others hairy; some thin and fragile, others tough and leathery.

When you look at a plant, first note how the leaves are arranged along the stem. Most leaves are *alternate*; they are attached one by one at different levels along the

stem so that no two occur at the same point. Other leaves are *opposite*, arranged in pairs along the stem. Less often, a plant's leaves are *whorled*—radiating out from the stem. Finally, there are *basal* leaves, which occur at the base of the stem. The edge of a leaf is called a margin by botanists. If the edge is smooth, it is designated as entire. Other leaves are serrated, with small, toothlike indentations along their margin. They are known as toothed leaves. Finally, some leaves have deep indentations; botanists refer to them as lobed leaves.

The distinction between simple and compound leaves may be the most confusing aspect of leaf anatomy. Simple leaves are just what they seem to be—individual leaves growing along a stem. Compound leaves are made up of individual leaflets. Leaflets look just like individual leaves, but are really sections of one larger leaf.

Many leaves have smooth surfaces, but others are covered with tiny hairs. In some plants, the hairs are soft and dense; in others, the hairs may feel almost like bristles.

USING A HAND LENS
Often it is difficult to decide which type of symmetry a flower displays, or to see the texture of the petals and leaves clearly, especially when flowers are minuscule. A good hand lens makes it easier to move in close and really look at what you see.

You can buy a suitable lens at any good photo store. Place the lens against your eye—not on top of the flower—and slowly move toward what you want to examine. When your subject suddenly springs into focus, you will be amazed at the world in front of you. A tiny yellow blossom will be transformed by subtle gradations of color and texture. You will also see how the edges of each petal differ slightly— some torn, some whole. And you'll be able to examine the texture of the petals and leaves more clearly; what at

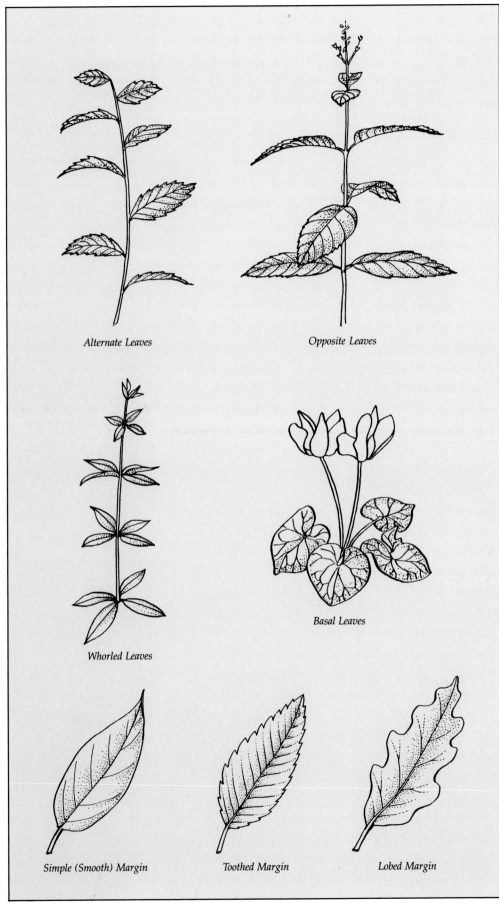

Alternate Leaves

Opposite Leaves

Whorled Leaves

Basal Leaves

Simple (Smooth) Margin

Toothed Margin

Lobed Margin

first looks smooth may actually be velvety or even covered with minute bristles. Finally, using a hand lens will make it much easier to study a flower's reproductive organs. Once you have worked with a hand lens, you will find it difficult to get along without one again.

EXERCISE

Gather a bouquet of flowers from your garden, your florist's shop, or a roadside near your home. Separate them into groups: those that you think are irregular and those that seem to have three, four, five, six or more equal parts. Then study each flower carefully, using a hand lens. Are the leaves smooth or covered with fine bristles? Are the petals soft or rough? Learn to look really closely at what you see.

Record your anatomical explorations in a notebook. Use a separate page for each type of flower. First note whether the flower is regular or irregular, then jot down how the leaves are arranged and other salient points, such as the number of petals. Don't limit your notes to scientific data, however. Ask yourself which features are most striking and which contribute most strongly to the personality of the flower. The petals? The leaves? The stamens? Are the petals brilliantly colored, with a definite shape? Or are they tiny, tinged with delicate color? You may find it helpful to augment your notes with simple drawings.

Understanding the structure of flowers can suggest different possibilities as you select flowers for your paintings. You may choose to work with varieties that have little in common structurally—baby's breath and calla lilies, for example—and then explore the fascinating visual contrasts. Or you may select types that are similar anatomically—zinnias and chrysanthemums, for instance—and use the repetition of similar shapes to create a powerful painting.

Selecting Flowers

*T*O PAINT FLOWERS skillfully you must understand which flowers work best in certain compositions. The delicacy of baby's breath, for example, can lighten up an arrangement that seems too heavy. Long, thin stalks of statice add drama and direction to arrangements that seem static. Some flowers are extremely effective when they are rendered alone; calla lilies, orchids, and amaryllis all come to mind. Other flowers, such as carnations, daisies, and baby's breath, seem more comfortable placed side-by-side with other blossoms.

The following information on eighteen popular flowers tells you how long they live, the kind of arrangements they are best suited for, and specific tips on conditioning them.

AMARYLLIS
These tall, beautiful flowers are spectacular enough to stand proudly by themselves. Count on them lasting from three to seven days. As you work with them, their heady fragrance will fill your studio. Note not only their brilliant color, but also the rich texture of their petals. Amaryllis is one of the easiest plants to bring into bloom indoors. In the dead of winter, this spectacular plant can easily flower in your studio.

BABY'S BREATH
Baby's breath stays fresh for up to one week, but if you totally ignore it and let the water it sits in evaporate, it will dry obligingly, too, leaving you with a supply of everlastings (dried flowers). The delicate structure of baby's beath makes it an ideal choice when you need to fill in holes in your arrangements—spots that seem empty once other, larger flowers have been put in place.

CARNATIONS
These sturdy plants can live as long as ten days. So many varieties exist that you can almost always find the color and size you want. Carnations look good massed together, yet work just as well when they are combined with other flowers. Their spicy fragrance makes painting them a pleasure.

CHRYSANTHEMUMS
Extremely durable, these plants may flourish for two weeks or even longer. They are a boon to the floral artist in autumn, when many other flowers have died. Like carnations, mums have been widely cultivated and today come in an almost limitless range of sizes and colors. Chrysanthemums look especially good when they are massed together in a vase.

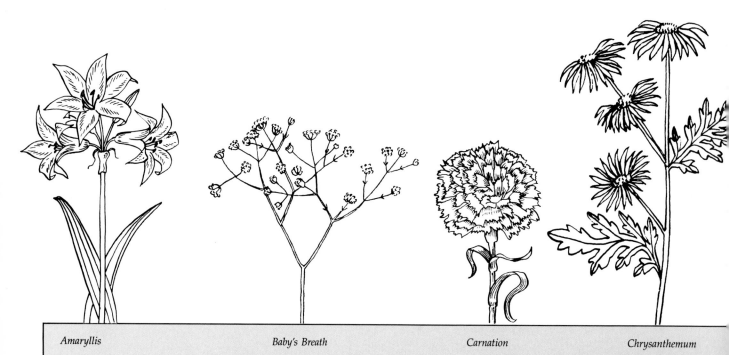

| Amaryllis | Baby's Breath | Carnation | Chrysanthemum |

DAFFODILS

The lifespan of a daffodil is difficult to predict. Some live as long as five days; others fade almost as soon as they open. No matter how long they survive, for the winter-weary they usher in spring. Today daffodils vary tremendously in color, size, and shape. Experiment and discover which types you enjoy the most. Buy daffodils before they open, then cut their stalks with a sharp knife. If you want to place them in a vase with other flowers, let them sit first for an hour or two in cool water until their sap stops flowing—it can damage other flowers.

DAISIES

These old, reliable standbys are the traditional symbol of innocence. Their simplicity and sturdy nature make them ideal painting subjects—many stand tall for more than two weeks. Before you put daisies in water, strip off most of their bushy foliage; it is especially vulnerable to bacteria.

FREESIAS

Florists have told me time and time again that these lovely flowers will live for five to seven days. Mine always wither within three days. Yet even if they do just live for a day or two, their graceful, elegant shape and sweet fragrance should thrill any artist. Trim off blossoms as they die and you will lengthen the lives of those that are still strong.

GERANIUMS

Don't pick these flowers. Instead, grow them in pots, then move the potted plants to your studio. At first, paint a single pot of blossoms. Later, try combining pots of geraniums with several other flowers that are easy to grow in containers. Petunias, sweet alyssum, wax begonias, and impatiens are all good choices.

IRISES

These beautiful flowers last for only a day or two. Even though they are short-lived, hundreds of different types are available. Some are called bearded irises; these plants have a fuzzy area on the center of the lower petals. No matter which type you choose, buy irises when they are still tightly closed or just beginning to open.

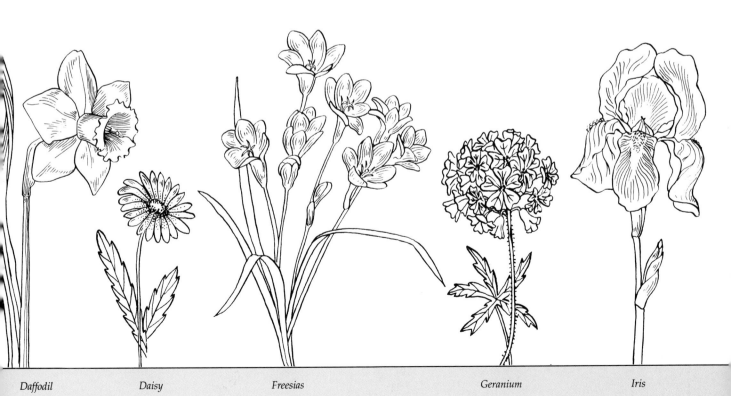

| Daffodil | Daisy | Freesias | Geranium | Iris |

Selecting Flowers

LILACS

Pick lilacs when they are still tightly closed and they may well live for a week or longer. If they are in full bloom when you harvest them, they should survive in water for two to three days. To make their magic last as long as possible, strip off most of their foliage and hammer the bottom of the stem. If you always try to render flowers as faithfully as possible, avoid lilacs; they are simply too rich in detail for most artists to draw or paint with scientific accuracy.

LILIES

Traditionally, lilies symbolize purity and immortality. Most live for at least a week; some last for a week and a half to two weeks. Lilies are beautiful in loose, open bouquets, either alone or mixed with other flowers. Try, too, to paint a single lily placed in a simple vase; its dramatic shape can be as strong visually as an entire bouquet made up of less spectacular blossoms.

NASTURTIUMS

Like geraniums, nasturtiums don't live long once they are cut. Plant them in window boxes, large pots, or hanging baskets, then work with them in your studio. The delicate blossoms are brilliant shades of red, yellow, and orange; the leaves are almost circular and as interesting as the flowers themselves. If you do pick them, draw and paint them rapidly, but don't throw away the blossoms when they start to fade. All parts of the nasturtium are edible, and the bright petals are a delightful surprise when added to a green salad.

ORCHIDS

So many types of orchids exist that a general statement about lifespan is impossible. If you grow them yourself, you know how long they live. If you buy them from a florist, ask how long they will stay fresh in water. Orchids are expensive subjects, so don't feel shy about requesting this information. Although orchids do mix well with other flowers in bouquets, they are really too lovely to be set amidst simpler blossoms. Try placing one sprig in a vial of water, then sketch it from various angles.

PEONIES

These lush, fragrant flowers live from three to seven days. The flowers are large—so large that in gardens the plants often must be staked to survive rainstorms and wind. Their heaviness is a problem, too, when you arrange them. If you are mixing them with other blossoms, place the peonies toward the bottom of the bouquet. To paint peonies by themselves, mass them together or add some strong green foliage to prop up the flowers.

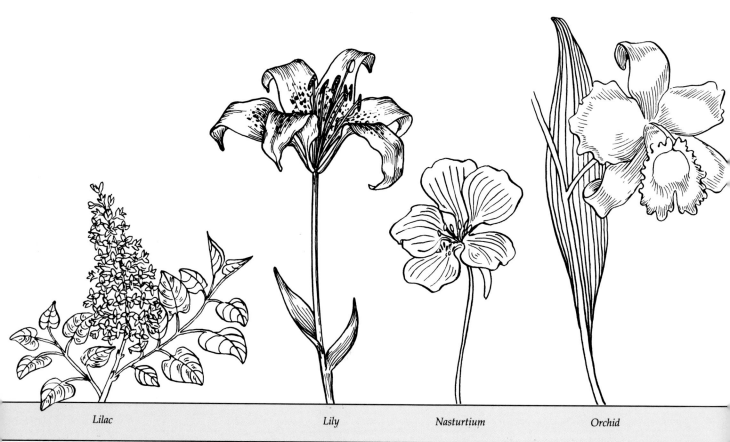

Lilac Lily Nasturtium Orchid

DRAWINGS BY MARY JANE SPRING.

ROSES

No flower has been favored with more love than the rose; art, history, and literature teem with references to the rose. Today roses come in an immense range of sizes and colors, and they are usually available all year long. Some types survive for almost two weeks. Most, however, begin to drop petals after just two or three days. Some artists shy away from painting roses—they are intimidated by the complex layers of petals. Others delight in capturing the lush delicacy of the rose. No matter which camp you belong to, be sure to remove foliage and thorns that will be submerged in your arrangement.

SNAPDRAGONS

These childhood favorites last about a week. Snapdragons are excellent mixed with other flowers; since they are strongly vertical, they add a dramatic accent to arrangements that lack power. And because they come in so many colors, you can easily find a snap to fit into your composition. If you have a garden, grow a variety of these flowers; they are easy to grow and easy to care for.

STATICE

Almost more than any other flowers, statice continues to hold its shape week after week. Like baby's breath, it dries well, too, and comes in handy in winter when fresh flowers are rare. Most statice plants are violet to blue, but pink strains are also available. These plants aren't really interesting enough to warrant detailed portraits, but they are immensely helpful in arrangements. The flowers are borne in long spikes, and like snapdragons can add drama and direction to mixed arrangements.

TULIPS

If you pick home-grown tulips, expect them to stay fresh for a few days. Those available from florists usually last longer. Buy them potted in containers and choose ones that are still tightly closed. Brought into a warm room, they will open quickly, then last for at least a week. Yet even under ideal conditions, tulips present a special challenge to the artist: they just won't stay in place. Overnight their stems swing to the left or right, or bend over just enough to disrupt a partially finished painting. Always capture the placement of tulips as soon as possible. Even if they move about, you will have the outline of your painting down and can refer to the flowers for specific information about color and value.

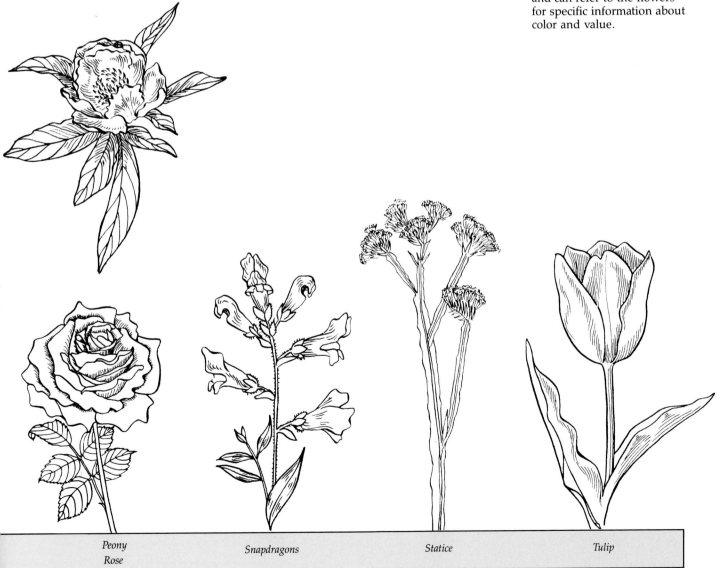

Peony
Rose

Snapdragons

Statice

Tulip

Caring for Flowers

UNLIKE OTHER still life subjects, flowers rapidly fade and die. Even when they are fresh, their shapes may change with every passing day. Keeping flowers at their peak is no mystery—all you need to know are a few simple rules.

TIPS FOR GARDENERS
Plant a cutting garden, a place where you can grow flowers for your own use, not just to impress the neighbors. Grow a good number of each species—enough to keep you supplied from spring through fall. In the spring you can pick tulips and daffodils; in the summer, a huge range of flowers; in the fall, chrysanthemums and other late bloomers.

Pick flowers as early in the day as possible. It's then that they are filled with the most moisture and are most resilient. Roses are an exception; gather them in the late afternoon.

When you go to your garden, bring along a bucket filled with lukewarm water and, as you pick your blossoms, put them inside it. The water will help to keep the flowers fresh until you can get back inside and condition them—an essential step. Just minutes after you cut flowers, they start to loose their ability to draw in water, and, unless properly cared for, they will die much sooner than they should.

In the garden, select flowers that are just about to bloom; if you choose those in full bloom they will probably start to fade within twelve hours. If you are harvesting lilacs, or other flowers that grow on trees or shrubs with thick, woody stems, gather them when they are still tightly closed. Cut the flowers with a sharp knife or gardening shears.

BUYING FLOWERS
When you buy flowers, choose ones that aren't quite open and have some spring left in their stems. Ask your florist how long you can expect the flowers to stay fresh; if the information you receive consistently bears no resemblance to reality, find another florist. Ideally, buy flowers from two or three shops. As soon as the shopkeepers learn what you like to paint, they can phone you with news of recent arrivals.

CONDITIONING FLOWERS
No matter where you get your flowers, conditioning is vital if you want them to stay fresh for days. To do it properly, all you need is a little time and patience.

Once you get your flowers home from the florist's shop or in from your garden, let them rest for an hour or two in lukewarm water. If you are working with tulips or other flowers that have long, springy stems, wrap the flowers in a cylinder of newspaper before you place them in water. Conditioning them this way helps keep them upright later when you place them in a vase.

After the flowers have rested, cut each stem diagonally with a sharp knife. Your aim is to expose as many cells as possible to clear, clean water. There are exceptions, however. Lilacs and other woody-stemmed plants last longest when their stems are smashed at the base with a hammer, then sliced vertically. Poppies and dahlias and a few other flowers exude a sticky sap; to

Diagonally Cut Stem

begin their conditioning properly, you must run their stems through a flame to seal the sap inside.

Next, start to strip away any foliage that will be beneath water once the flowers are arranged. If you are conditioning roses, make sure you get rid of their thorns, too. Foliage and thorns decay rapidly in water; bacteria thrive on them. The flowers that you want to draw and paint for days can wither within hours unless you cut off superfluous greenery.

Once all the stems have been cut, hammered, or singed and the foliage stripped, let the flowers soak in water for two to three hours before you begin to arrange them. Ideally, you should remove flowers from their container every day, rinse the stem, slice it again diagonally, clean the container, then replace the blossoms. If you are painting a huge floral bouquet, obviously this won't work. But if you are concentrating on just one or two—or even five flowers—do try to refresh them daily.

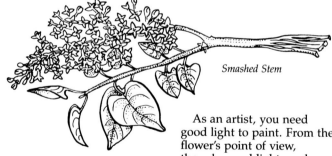

Smashed Stem

As an artist, you need good light to paint. From the flower's point of view, though, good light can be killing. Compromise; when you aren't working with your subject, place the flowers in a cool, dark place. You'll be rewarded with blossoms that stay fresh and last for days.

DRAWINGS BY MARY JANE SPRING.

Charles Le Clair, **Cut Flowers,** *1985, watercolor on paper, 60" × 40" (152.4 × 101.6 cm), courtesy of More Gallery, Philadelphia.*

Arranging Flowers

A SINGLE DAYLILY in a simple kitchen glass can be as beautiful as a lavish display of orchids in a crystal vase. Let your own taste guide you when you are setting up compositions. If you want to go beyond simple setups, though, explore the art of arranging flowers and discover the materials that can make it easier to keep flowers in place.

SUPPLIES

The following tools make it easy to work competently with flowers: garden shears plus a sharp knife, green florist's foam, florist's tape, floral frogs, floral pinholders, finely meshed wire, flower vials, sphagnum moss, clear marbles or dark rocks, and charcoal.

Green florist's foam helps anchor flowers. Cut the foam to fit the inner lip of your container and, if necessary, tape the foam securely to the edge of the vase. Next, push the flower stems through the foam. Foam works best when it's placed in an opaque container. It is possible, though, to camouflage it with foliage.

Flower frogs and pinholders help, too. Frogs are heavy glass or ceramic objects that sit in the bottom of a vase. They have cylindrical indentations into which you place flower stems. Flower

Floral Frog

pinholders also sit on the bottom of a vase; their surface is covered with pinlike protrusions onto which you impale the stems. If you find yourself without foam, frogs, or pinholders, you can stretch finely meshed wire across the rim of your container. Anchor the wire with tape, then push the stems through the wire.

Flower vials look like test tubes; they are long and thin, with a rubber seal at one end. The seal is pierced with a small hole. Using

Flower Vial

these inexpensive containers is easy. Fill one with water, replace the seal, then gently press one or two stems through the hole. You can place the vials anywhere—even in containers that aren't waterproof. To fill a wicker basket with flowers, for example, first fill a plastic container (one that will easily fit into the basket) with sand, then place the container in the basket. Set as many individual vials as you like into the sand, then cover the vials with sphagnum moss.

The rocks and marbles are both decorative and practical; place them in the bottom of a clear glass vase for a handsome accent and to help the flowers stay where you want them. The natural charcoal helps keep water clean. Look for it at pet stores; in aquarium filters, it continually cleanses the water in the fish tank.

SELECTING THE VASE

Choosing an appropriate container for your flowers is an exciting challenge. A vase may be small or large, elegant or homely—what it looks like matters little. What does matter is the harmony between the flowers and the objects into which they are placed.

In creating a harmonious effect, many elements come into play—color, shape, balance, mood, proportion, and texture. The rich, warm tones of an old copper bowl set off the golds and reds of autumn mums. A large bouquet of red and white carnations is attractive placed in an opaque milk-glass jar. Just as a silver or crystal vase immediately adds a note of formality to your arrangement, putting a handful of daisies or wildflowers into an old pottery crock or a wicker basket instantly creates a warm, casual feel. A single long-stemmed rose is perfectly at home in a simple bud vase. The rough texture of pussy willows blends in easily with that of a wicker basket.

Make sure that the vase you choose is correctly proportioned. In general, florists choose to make flowers two to three times as tall as the container. If a bouquet looks top heavy once you have set it in a vase, move it to a new container, reduce the number of flowers, or cut a few inches from their stems. If a

bouquet looks wan and lonely in a huge cut-crystal vase, move it to a smaller container.

Whenever you place flowers in a crystal or glass container, their stems become as important as the flowers themselves. Strong, linear stems, like those of tulips, can add an elegant touch to the simplest composition. On the other hand, flowers with a lot of bushy foliage—daisies, for example—are poor choices for glass or crystal containers. The foliage rapidly decays, the water becomes tainted, and the flowers die.

To add an extra touch of grace to your arrangements, fill the bottom of a clear vase with smooth black stones or marbles. With their long, thin stems, tulips, daffodils, and lilies are set off beautifully by this treatment. The stones and marbles do more than add a dash of visual excitement—they also help anchor the flower stems.

USING ORNATE VASES

Highly decorative vases can be powerful enough to make a statement on their own. On page 23, instead of adding flowers to his setup, Michael McCloskey *evokes* flowers by his painting of the vases' delicate floral motif and his emphasis on the petal-like rims.

Experiment on your own with ornate vases with a floral pattern. Try, as McCloskey does, to convey the feeling of flowers through the vases alone. Then take a different approach—find blossoms that aren't overwhelmed by your container and make both elements work together. You may need to simplify certain details or shift your viewpoint to combine the vase with actual flowers.

DRAWINGS BY MARY JANE SPRING.

Michael McCloskey,
Two Vases,
1978, watercolor on paper,
30" × 22" (76.2 × 55.9 cm),
collection of Edward Kipp.

	Container	Flowers	Effect
	Rugged containers such as crockery creamers, pitchers, or pots	Daisies, daffodils, black-eyed susans, tulips, goldenrod, mums, zinnias, or even clover—simple flowers with definite shapes	Casual and unstudied
	Crystal, china, or glass vases	Lilies, freesias, irises, or orchids	Elegant and formal
	Wicker baskets	Potted flowers—tulips, chrysanthemums, zinnias, begonias, or anything else you can grow outside, then bring inside	Informal and rustic
	Inexpensive glass containers, including carafes, beakers, flasks, or even old juice glasses	Wildflowers or flowers like anemones, daisies, or carnations—familiar flowers that almost anyone can gather together	Spontaneous and homey
	Silver vases	Elegant flowers—roses, amaryllis, irises, dahlias, orchids, or birds of paradise	Graceful and stately
	Brass or copper containers	Flowers that bloom in autumn—chrysanthemums, for example	Warm, yet elegant

FOCUSING ON COLOR

As you select and arrange your flowers, be aware of how their colors interact. You can, for example, use color to create mood. Warm shades of yellow, red, and orange usually suit casual arrangements. Since their colors tend to advance visually and to dominate other hues, they also help to fill out skimpy floral arrangements and to keep the eye moving around an arrangement.

Cool shades of blue, lavender, and purple often work well when you want to create a more formal mood. If you want to add other flowers to a formal blue or purple bouquet, try white blossoms or ones that are pink or pale magenta. To make your blue arrangement less formal, add a handful of bright daffodils or other yellow flowers to provide contrast.

You can use strong, intense color—a rich purple or a brilliant crimson, for example—much as you use warm hues. Strong colors advance visually and create a sense of movement and excitement. Muted hues—such as pale pinks, grayed violets, and subdued yellows—can add a delicate note and help to create a soothing effect.

Because color is such an important part of painting flowers, a section of this book is devoted to it alone. Color offers you endless possibilities—try to explore as many as you can.

USING FLOWER SHAPES

Shape is just as important as color in arranging flowers. Round, compact flowers like zinnias and chrysanthemums help fill in arrangements that are mostly made up of more exotic or strongly linear blossoms—flowers such as lilies, statice, or snapdragons. In addition, their symmetrical shapes create a calm, balanced feeling. These flowers also look good massed together in squat, rounded containers, such as ginger jars.

Tall, elegant flowers like lilies and orchids can estab-

lish a sense of direction, looking at them, the eye sweeps upward and out. They also add a graceful or dramatic touch to floral bouquets that seem bland and uninteresting.

Delicate flowers such as baby's breath come in handy to fill empty spots after other flowers are in place. They can also soften arrangements that seem too harsh or too angular.

FOSTERING INTIMACY

Both the containers and the flowers are important in creating a painting's mood, as you can see in Carol Bolt's watercolor. Resting on top of a doily, the blue and white creamer suits the bouquet of warm pink and orange flowers perfectly. Because the creamer is short and squat, the flowers easily spill out over its lip. A more formal container would spoil what

makes this painting so effective—the cozy, homey feel the artist has achieved by balancing the proportions and the colors of the flowers and their container. Notice how the floral motif of the creamer is echoed and augmented by the flowing curves of the flowers. Also observe how the closeup view from above adds to the sense of intimacy.

Carol Bolt,
Sweet Peas with Blue Creamer,
watercolor on paper
24" × 23" (61 × 58.4 cm),
collection of Ellen Harris.

25

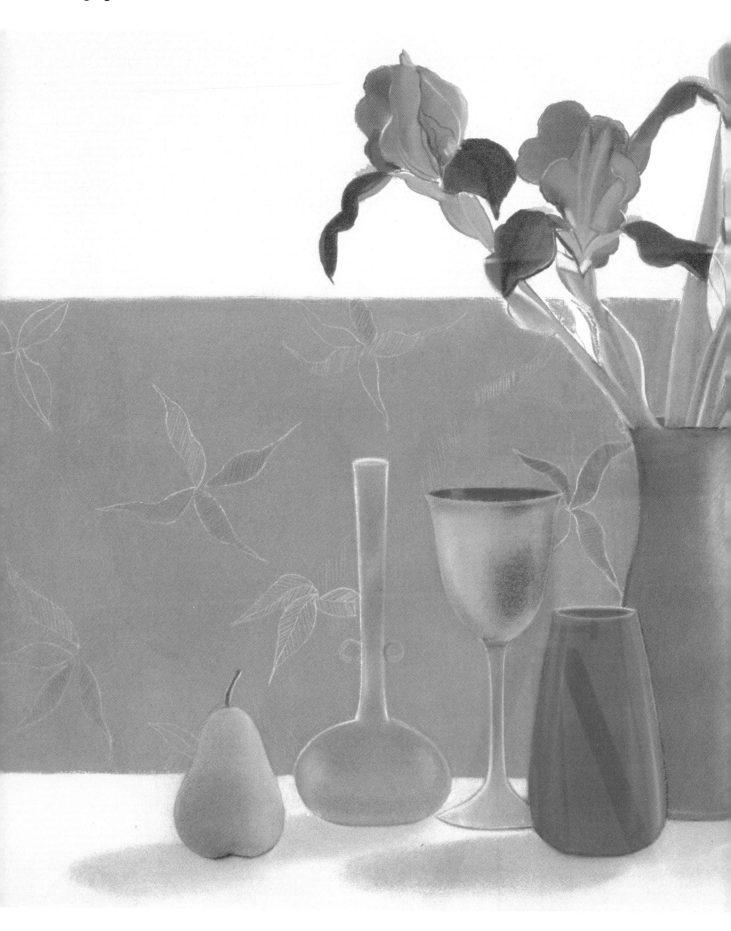

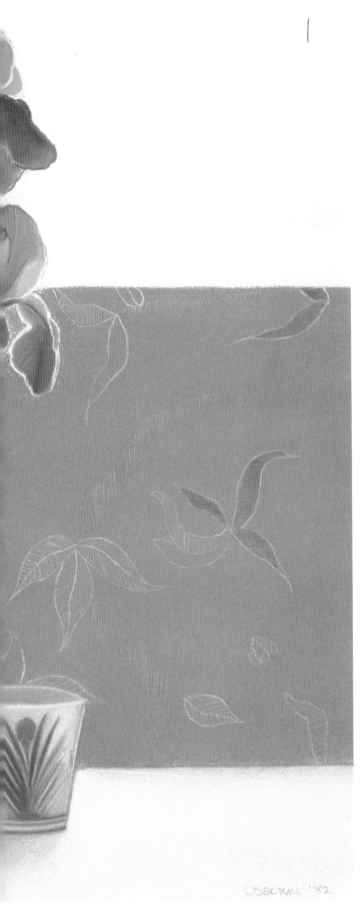

ESTABLISHING ORDER

The objects in Elizabeth Osborne's still life seem carefully arranged, with an eye to balancing color and shape. The simple geometry of the pear, vases, goblet, and glass provide a counterpoint for the eccentric line of the irises. Although the pattern in the background echoes the liveliness of the irises, its strong blue shape keeps this from becoming too assertive. Notice the repetition of yellows, blues, and oranges in the objects and how they set up a vertical rhythm against the horizontal backdrop. All this contributes to a feeling of tranquil order. The more you look at this still life, the more you realize that every choice is important.

ADDING GREENERY

In arranging flowers, foliage may seem, at first, much less important than the blossoms. In fact, the greenery you select is equally important. The shapes of the leaves you choose are a strong compositional element; those that have jagged, toothed edges are obviously more dramatic and exciting than those with smooth edges. You can manipulate the placement of the stems and leaves, too. Leaves that are clustered within a bouquet seem calmer and less dramatic than those that jut out beyond the flowers. Color is equally important. Bright spring-green leaves are obviously warmer than silvery green leaves and better suited to a casual bouquet made up of yellow, orange, and red flowers.

EXERCISE

Experiment with different flower arrangements to learn how every element you select affects the setup and how even the same flowers can have a different impact when they are placed in different situations.

Instead of beginning with the flowers, first choose the foliage or the container, and make it the focus of your setup. Decide what intrigues you—is it the delicate tracery of the leaves or the graceful curves of your vase? Then select flowers to accentuate this aspect. Shifting the focus away from the flowers as the primary subject may make you more aware of their contribution in terms of line, shape, and color.

Now work with the blossoms as the focus. Choose a flower that you like—a daisy, a daffodil, a tulip, a rose, or whatever else strikes your fancy—and use it in different ways. First, create an arrangement that suggests a portrait of the flower. Next, use a cluster of the same flowers to set up a rhythm that coincides with the "spirit" of the flower. Move on to explore different expressive possibilities. Can you use the same flowers to evoke a calm and a lively mood? You can add other flowers to your bouquet or use different vases, but try to concentrate on how the actual grouping of the flowers affects your response.

Finally, try breaking obvious rules. Team up a delicate orchid with a rugged crockery pot. Or place delicate daisies in an elegant crystal vase. Try, too, to create an elegant floral statement with simple daisies, or an informal arrangement with roses.

Elizabeth Osborne,
Still Life with Iris,
1982, pastel on paper,
29¾" × 37½" (75.6 × 95.3 cm),
private collection.

Drawing Flowers

*S*KILLFUL DRAWING underlies all good painting. If you are unsure about your ability to draw, the best way to become more confident is to draw constantly. Carry a sketchpad with you wherever you go and get in the habit of using it.

It doesn't matter what tool you use—it can be a pencil, a marker, or even a ballpoint pen. The point is to train your hand to respond to what you see, immediately and instinctively, without a lot of fuss and bother. This is not an easy task. Most people have difficulty understanding—and rendering—what they actually see.

Proportion and perspective can be especially difficult. To jump over this hurdle, don't limit your sketching to botanical subjects. Study the human figure, too, as this may make it easier to comprehend the proportions of a flower. Similarly, landscape drawing can help you grasp the principles of perspective.

EXERCISES

The exercises on this spread and the next are designed to make drawing flowers—and other subjects—easier. If you lack confidence in your drawing skill, work through the exercises slowly. Devote as much time as possible to each exercise; only through prolonged work will it become easy to render what you see.

Use whatever tools you are most comfortable using. If you have always drawn with an HB pencil, though, it may be time to experiment. In addition to hard and soft pencils, try any or all of the following: markers, charcoal pencils, vine charcoal, conté crayons, bamboo pens, rapidograph pens, and ballpoint pens. And don't forget color pencils; drawing with color is an exciting challenge.

Also explore different kinds of paper. If you are executing many quick sketches, try drawing on newsprint. If you have focused on a complicated, time-consuming subject,

dark green

flat green, darker toward stem

though, use a high-grade paper, one that will stand up to prolonged work.

Be aware of subtle nuances. Every time you approach a flower, carefully study how it grows. Is it upright, or does it bend to one side? Does it grow from a vine? How are its leaves arranged? Do the leaves or the petals have an obvious texture? Are the flowers borne in clusters or do they grow singly from the stem? The more thoroughly you understand your subject, the more accurate your drawing will be.

If, at first, you are disappointed with what you accomplish, don't lose heart. Study your mistakes and learn from them. Ask yourself: Why am I unhappy with this drawing? What makes it look wrong? The shapes? Balance? Perspective? A misunderstanding of the relationship of the parts to the whole? Once you understand what doesn't work, try to draw your subject again, working from your original drawing and from your memory.

1. Loosen up with gesture drawings. Work rapidly, trying to capture the overall feel of the flower—its personality. Don't pay attention to the outline, or to any of the details. Try to capture the spirit of the whole. Your gesture drawings may not be comprehensible to anyone but you. It doesn't matter. Think of them as a kind of visual shorthand, a shorthand that only you can understand.

2. Now turn to contour drawings. Render the edges of what you see. Keep your eyes on your subject, not on the paper, and work slowly and carefully. Don't lift your pencil; instead, use a continuous line, following what you see. When you do finally look at the paper, don't be dismayed at the results. At first your drawings may seem undecipherable, but gradually they will improve. Remember, it takes years of practice for the eye and hand to work together effortlessly.

*Drawings by
Karen Segal (top left),
Marian Appellof (bottom left),
and Jean Shadrach (this page).*

Drawing Flowers

3. *Gather together five different flowers and analyze them carefully, reducing each to its basic shape.* Keep your sketches simple, with a minimum of detail. Instead, focus on the underlying geometric form of the flower. Is it elliptical, bell-shaped, or cuplike? If you understand a flower's basic structure, the details will make sense when you add them later on.

4. *Now draw the same flower from many different angles.* First, study the flower head-on, then from below and above. Next, draw it seen from the left, then from the right. If you already understand the flower's basic geometric structure, you'll be better able to see how it changes in perspective. Viewed head-on, a daisy is circular; hold it in midair at an angle and it becomes elliptical.

5. *Make value sketches of different flowers.* Explore different ways of creating dark tones—from parallel strokes to cross-hatching to broad sweeps laid in with the side of a pencil. Try to define the form of the flower solely with light and dark tones, without restoring to outlines.

6. *Draw the space around a group of flowers—the negative space.* Instead of focusing on the flowers themselves, concentrate on the shapes *between* the flowers. Begin loosely, getting down the overall shapes of the negative areas. Then gradually refine the edges of these areas. If you do this accurately, the shapes of the flowers should emerge.

7. *Explore different ways of using line,* from strong, sharp pencil strokes to delicate, calligraphic notations. Try drawing the same flower with a very soft pencil (5B) and a very hard one (6H). Sometimes using a different medium can "force" you to draw differently and thus open up new approaches.

8. *Do detailed studies of flowers.* Set aside four hours to work on a single drawing. Use

*Drawings by
Jean Shadrach (this page),
Karen Segal (top right),
and Marian Appellof (bottom right).*

pencil to show subtle shifts in value and texture. Try stippling, cross-hatching, and other drawing techniques to create an accurate rendition of what you see. Next, spend several hours concentrating on details—draw stamens, pistils, or a single leaf or petal. This exercise makes you concentrate on understanding what you see; by paying close attention to your subject for long periods of time, you will learn how it is structured—how each part of a flower relates to the next.

9. Study a flower carefully for five or ten minutes, then draw it from memory. When you have completed your drawing, compare it to your living subject. How do they differ? How did you interpret what you see? Did you concentrate on details or on the flower's overall shape? What helped you express the personality of the flower? What would you do differently if you had another chance?

10. Draw the same flower two ways. First, make it as delicate as possible. Next, render it with bold, dramatic strokes.

11. Begin to experiment with color by drawing with colored pencils. Because the pencils are somewhat transparent, the white of the paper shines through strokes that you lay down lightly. Heavier color results when more pressure is used or when the colors are layered.

12. Finally, just for fun, create an imaginary flower. You can draw a composite—combining the petals from one flower, the pistils and stamens from another, and the leaves from yet another. Or you might exaggerate different aspects of an existing flower, transforming it into something else. Whatever approach you choose, pay attention to the relationship between the parts so that the flower is "believable" as a whole.

Learning from Botanical Illustration

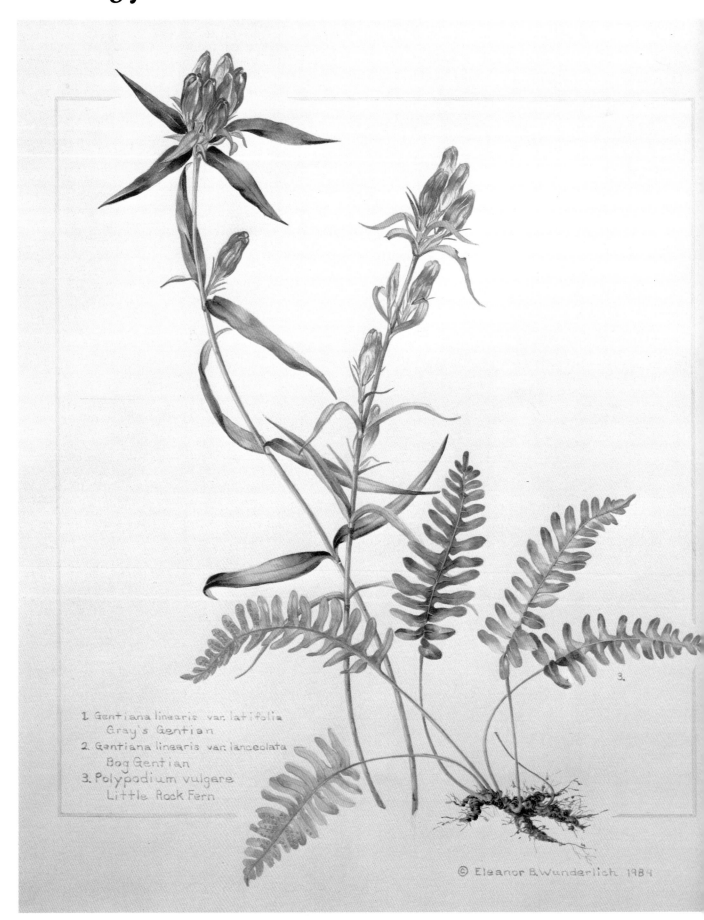

1. Gentiana linearis var. latifolia
 Gray's Gentian
2. Gentiana linearis var. lanceolata
 Bog Gentian
3. Polypodium vulgare
 Little Rock Fern

© Eleanor B. Wunderlich 1984

*T*HE ART OF botanical illustration demands total fidelity to nature: every detail of a plant must be captured accurately. By studying botanical drawings, you will become much more intimately acquainted with flowers than ever before. You will also learn a lot about composition, for botanical artists carefully design the works that they create. The way these "scientific" artists arrange their studies of flowers, fruit, and twigs can be as expressive as a loosely executed watercolor.

SCIENTIFIC TERMS

A familiarity with scientific nomenclature is essential if you are to communicate clearly with other botanical artists and with scientists. Scientific names aren't that difficult to learn, and they are far more accurate than common names. What is known as coralberry in one part of the country is called Indian currant in another, but wherever you go, its scientific name—*Symphoricarpos orbiculatus*—is the same. Each scientific name is made up of two words. The first, or generic name, is that of the genus to which the plant belongs. The second name, or specific epithet, identifies one particular plant within that genus. No two plants have the same scientific name.

EQUIPMENT

Even if you have little interest in scientific illustration, try your hand at it and see what you can learn. You will need hard lead pencils—

ones that don't smudge— and an eraser that won't damage the paper. The paper you work on should be sturdy and relatively smooth; if it has a definite texture, it may be impossible to render details accurately. If you work in pen and ink, be careful to keep the weight of your line uniform. This is especially important if your drawings are to be reduced in reproduction. Lines that are fine in places and broad in others make it difficult to understand fine anatomical points.

If you wish to work with color, choose either watercolors or acrylics. The transparency of these water-soluble media is ideal for painting plants; the white of the paper shines through the color, creating a natural, luminous effect.

A hand lens is essential; with it you can explore all the complex details that make up a plant. If you become more deeply involved in botanical illustration, you may wish to buy a dissecting microscope. For detailed information on equipment, and every other aspect of botanical illustration, refer to Keith West's *How to Draw Plants* (Watson-Guptill Publications, New York, 1983). There is no better guide to the subject. West explores every aspect of drawing plants—from the history of botanical illustration to materials, concepts, and practical information on handling living plants.

CHOOSING YOUR SUBJECT

One purpose of botanical il-

lustration is to record as much information as possible about a particular plant. Consequently, try to choose a typical specimen rather than one that has unusually small leaves, unusually large petals, or unusual coloration.

The sturdiest plant is usually one still in soil, potted and easily moved to your studio. If you are working with cut flowers or flowering branches that have been removed from a tree or bush, keep the stem in water and spray the plant occasionally with a fine mist.

Be sure to select the plant when its blossoms are just about to open or partially open. If they are too tightly closed, they may never open once they are cut. If they are fully open, the petals may start to drop before you have finished working with your subject.

EXAMINING YOUR SUBJECT

Botanical illustration begins with a thorough study of the plant. Although it may seem tedious work at first, measuring the larger parts of a plant makes it much easier to draw and paint that plant accurately. Measure the stem, the leaves, the petals, and the sepals, then carefully execute a simple line drawing that shows the relationship of each part to the next. As you work with your plant, you can refer to your measurements and sketch if the plant starts to wither. Color notes taken at the start of your work are helpful for the same reason.

As you measure the plant, you will become acquainted

with its overall proportions. Now examine the plant with both the naked eye and your hand lens. As you study the plant, ask yourself these questions:

☐ Are the leaves opposite, alternate, whorled, or basal?

☐ What kind of symmetry do the flowers display: radial or bilateral?

☐ Are the leaf margins smooth, toothed, or lobed?

☐ What is the texture of the leaf surfaces? The petals? Are the veins conspicuous?

☐ Is the plant's stem woody?

☐ Are the stamens and pistils conspicuous?

☐ Is there anything unusual about the plant that should be stressed? If, for example, the undersides of the leaves are white and felty, you will have to show both sides of the leaves in your drawing.

Only when you feel thoroughly comfortable with the plant should you begin your illustration. At this point you also need to consider the overall design. Should the plant be centered on the paper? Or should you place the stem on the right to show off a cluster of flowers growing from the left side of the stem? Also ask yourself if you need small drawings of details to adequately convey a sense of the plant's anatomy. No matter how closely you try to duplicate what nature has produced, another goal is equally pressing: creating a beautiful picture. Even in the exacting realm of botanical illustration, at some point the needs of the picture take over.

Eleanor Wunderlich,
Gentiana linearis,
1984, watercolor on paper,
15½" × 13" (39.4 × 33 cm).

Learning from Botanical Illustration

R EGARDING her botanical illustrations, Eleanor Wunderlich explains, "I use the same techniques in rendering a picture that were used two hundred years ago. So does everyone else doing this kind of work, as far as I can tell. There is only one way to do an accurate depiction of a flower or plant, and that's carefully."

In addition to studying her subject thoroughly, Wunderlich carefully plans the design to show the plant to its best advantage and to effectively convey pertinent botanical information. When you look at her depiction of witch hopple, or hobble bush (*Viburnum alnifolium*), you see all its important identification characteristics —the shape of its leaves and petals, plus the stem and the fruit. The way the plant is laid out on the page, branching at an angle upward and to the side, clearly suggests the way it grows. Notice, as well, how the bright red berries in the lower right corner balance the rest of the composition.

With *Trillium undulatum*, Wunderlich depicts the plant in several ways: she shows the flower open, from both the front and the rear, and she shows the bright red seed casing, with a cross-section below. Note how the leaves are depicted at all stages of their development—old torn leaves are presented next to young fresh ones. This painting, however, goes beyond mere presentation of scientific information. The simplicity of the overall design, with the graceful curves of the stems and leaves, conveys the beauty of the plant.

EXERCISE
By studying Wunderlich's work and other botanical illustrations, you can learn a lot about design and how to balance different elements on a sheet of paper. Take your favorite flower and examine it carefully, following the guidelines on page 33. Pay particular attention to the relationship between the stems, leaves, and blossoms. Now, using two or three views of the plant, plan a composition that highlights this relationship. You don't need to do a detailed drawing of the flower. Instead, concentrate on the main shapes and their arrangement on the paper. With a tulip, for example, you might play with the contrast between a tightly closed flower standing upright and a more open blossom bending over.

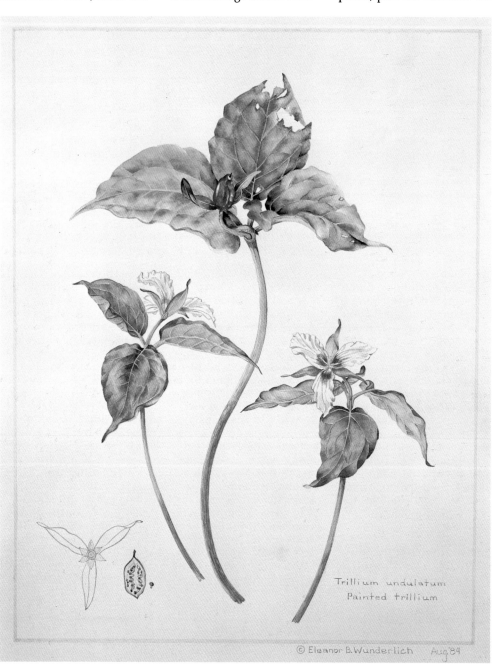

Eleanor Wunderlich,
Trillium undulatum,
1984, watercolor on paper,
15" × 12" (38.1 × 30.5 cm).

Eleanor Wunderlich,
Viburnum alnifolium,
1984, watercolor on paper,
14½" × 11" (36.2 × 27.9 cm).

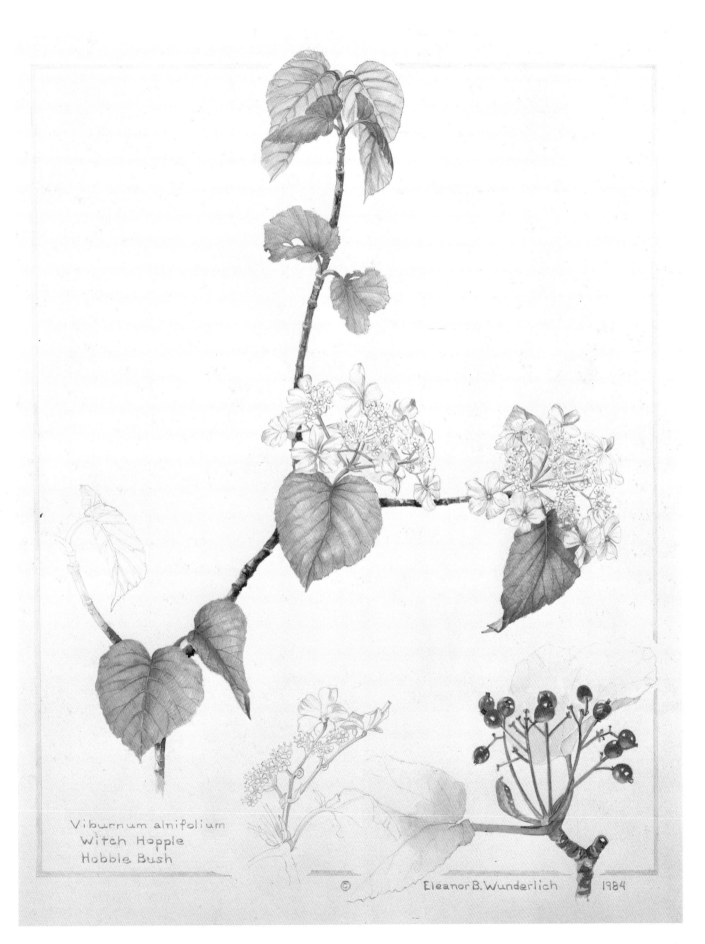

Viburnum alnifolium
Witch Hopple
Hobble Bush

Eleanor B. Wunderlich 1984

Learning from Botanical Illustration

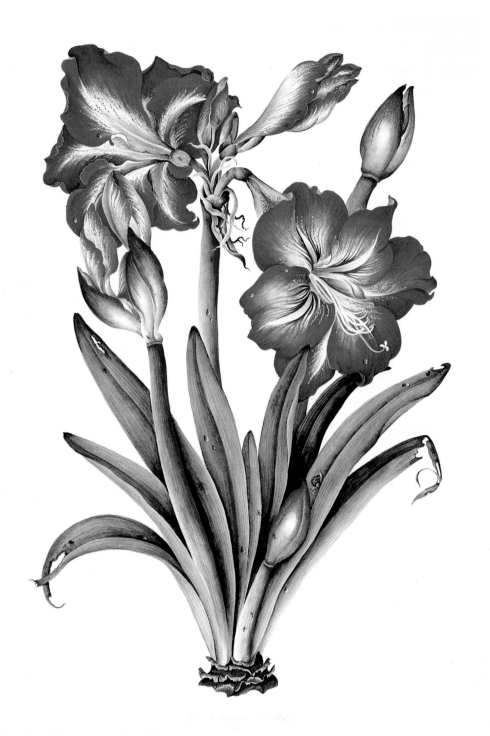

Susan Sergel Monet, **Amaryllis,** *1985, watercolor, 22″×16″ (55.9×40.6 cm), collection of Monet Fine Arts.*

*S*USAN SERGEL MONET has said of the way she approaches her subjects, "My perspective is like that of a dentist; my field of focus is about three to six inches." The clarity of color and form you see in her paintings often requires more than one hundred hours of work.

Before Monet begins to paint, she loosely sketches her subject, then works on layers of tracing paper, until she achieves an effective composition. After further study of her subject, she does a very accurate drawing, lightly pencils the back with an H pencil, and transfers it.

Monet then uses up to seven layers of color to achieve the color intensity that characterizes her botanical illustrations. She works on one element at a time, in a relatively small area, so that her paper is never really wet. Each layer of wash is allowed to dry thoroughly before the next is added. At times, to render details on top of the layered color, she uses an opaque white (Dr. Martin's bleed-proof white), by itself or mixed with other hues. Because this white has a slightly bluish cast, she reduces the amount of blue she would ordinarily use in whatever color she is mixing.

Although Monet's work is carefully planned in advance, she does make additions and alterations as she paints. If mistakes occur, she wets the area, gently scrubs with a brush, blots, and lets everything dry completely. If color still remains, she repeats this process two or three times. As a final step, she scrapes the paper lightly with a razor to remove unwanted pills.

DETAILS
The ladybug and ants that wander over the amaryllis were added after the rest of the painting was complete. The droplets of water were finishing touches, too. Monet peers through a magnifying glass as she renders these minute details.

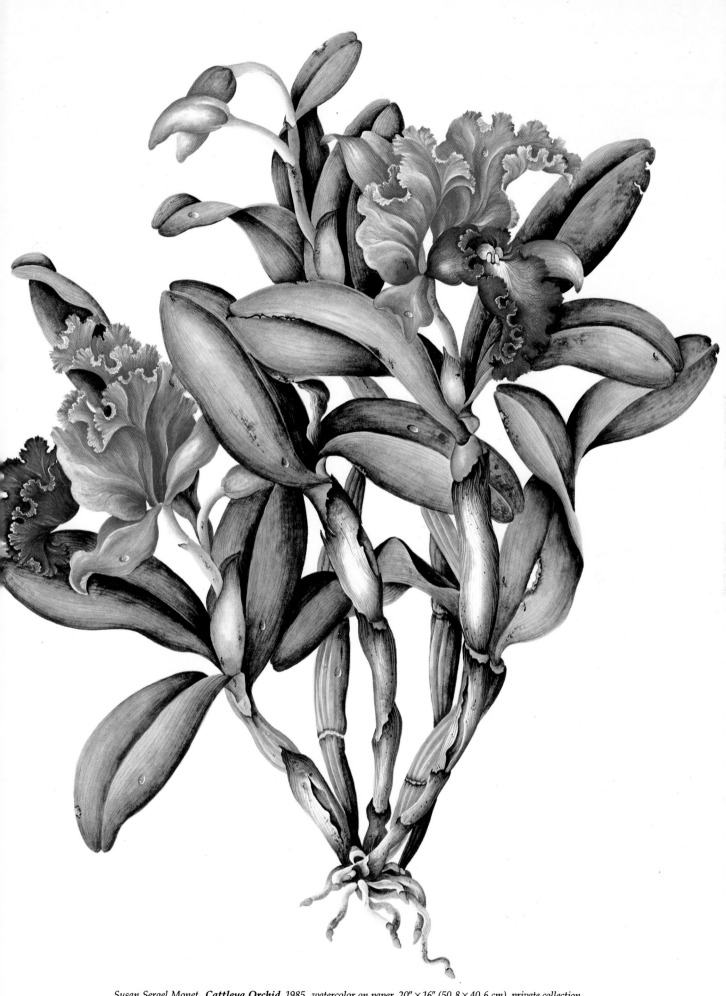

Susan Sergel Monet, **Cattleya Orchid**, *1985, watercolor on paper, 20″ × 16″ (50.8 × 40.6 cm), private collection.*

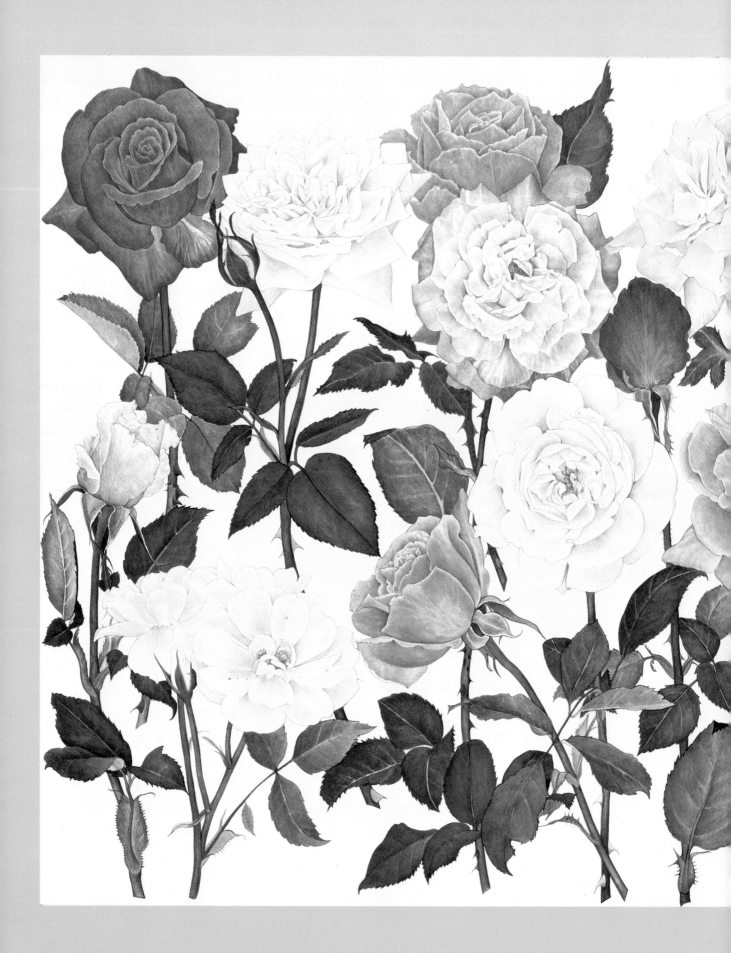

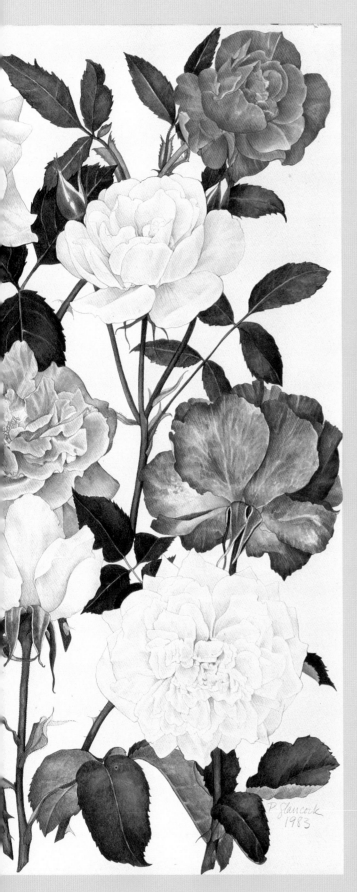

WORKING WITH COLOR

ALONG WITH more ephemeral things like grace, beauty, and elegance, artists are drawn to flowers because of their incredible shapes and their magnificent colors. Studying color and understanding the principles that govern how it is perceived can help you capture what you see in front of you when you begin to paint flowers.

The best way to learn about color is to actually work with it. Use the exercises in this section as a starting point and then continue exploring on your own. As you paint, take time to look at how the colors you put down are working together on your paper or canvas. Most artists find they continually discover new things about color and its interactions with each new painting they do. There is always more to learn.

Pamela Glasscock,
16 Roses, 1983, watercolor on paper,
22½" × 30" (57.2 × 76.2 cm),
collection of the artist,
photo by D. James Dee.

Understanding Color Characteristics

*E*VERY COLOR has three characteristics—hue, value, and intensity. In the abstract, these characteristics seem easy to understand, yet in practice they often prove difficult to master. Understanding them thoroughly makes it possible for you to see the range of effects inherent in each color. That knowledge, in turn, is the basis for one of the most fascinating and creative areas of painting—color relationships.

The word *hue* refers to the common name of a color. Red, yellow, and blue are all hues; so are violet, green, and orange. Hue alone, however, does not describe what you see when you study a brilliant red amaryllis. Of course the flower is red, but that information has to be qualified by two other terms—value and intensity.

Value measures how light or dark a color is in relation to black and white. White is said to be high in value, black low. On a scale of zero to ten, pure white is ten, black zero. If you have difficulty determining the value of a hue, try squinting. As your eyes become less focused on details, light-, dark-, and medium-value tones become easier to see. If squinting doesn't help, try imagining how a scene would look if it were photographed in black and white.

A hue's *intensity* is that color's brilliance or strength. Imagine sweeping a brush through a pool of scarlet ink. See the color on the paper. Now imagine how that same pool of scarlet would look if dull green or gray were added to it. The brilliance of the red would be diminished—it would be less intense and less brilliant, and would recede when it was placed next to the original scarlet hue.

Yet another characteristic of color is *temperature*. Reds,

yellows, and oranges are said to be warm; blues, violets, and greens cool. Warmer colors generally tend to advance, cool colors to recede. The warmth or coolness of a color also affects the mood it creates. The warm hues are usually associated with lively, animated subjects; the cool ones with more reserved and formal ones. Every color has a psychological impact that varies from person to person.

Color temperature, however, is a relative phenomenon. Seen against a brilliant reddish-orange backdrop, a bluish-green hue seems very cool; but placed next to a dark steel blue, the same bluish-green may seem relatively warm. Within each temperature range, relativity is also important. Some warm hues are relatively cool, and some cool hues are relatively warm. Alizarin crimson, for example, is considered a cool red; cadmium red, a warm red. If you are painting a warm, sunstruck group of autumn mums, you'll probably want to work more with cadmium red.

Carol Bolt,
Parrot Tulips and Iris,
*watercolor on paper,
24″ × 23″ (61 × 58.4 cm),
collection of Missouri
Botanical Gardens, St. Louis.*

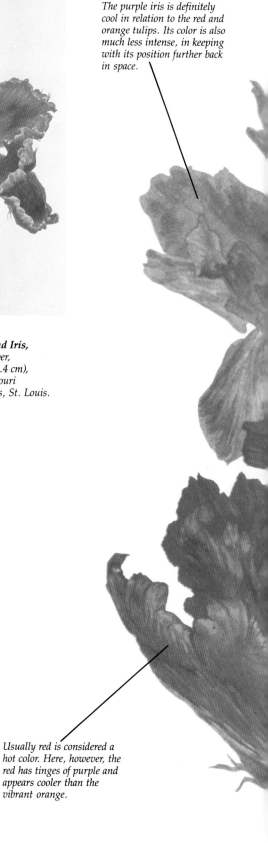

The purple iris is definitely cool in relation to the red and orange tulips. Its color is also much less intense, in keeping with its position further back in space.

Usually red is considered a hot color. Here, however, the red has tinges of purple and appears cooler than the vibrant orange.

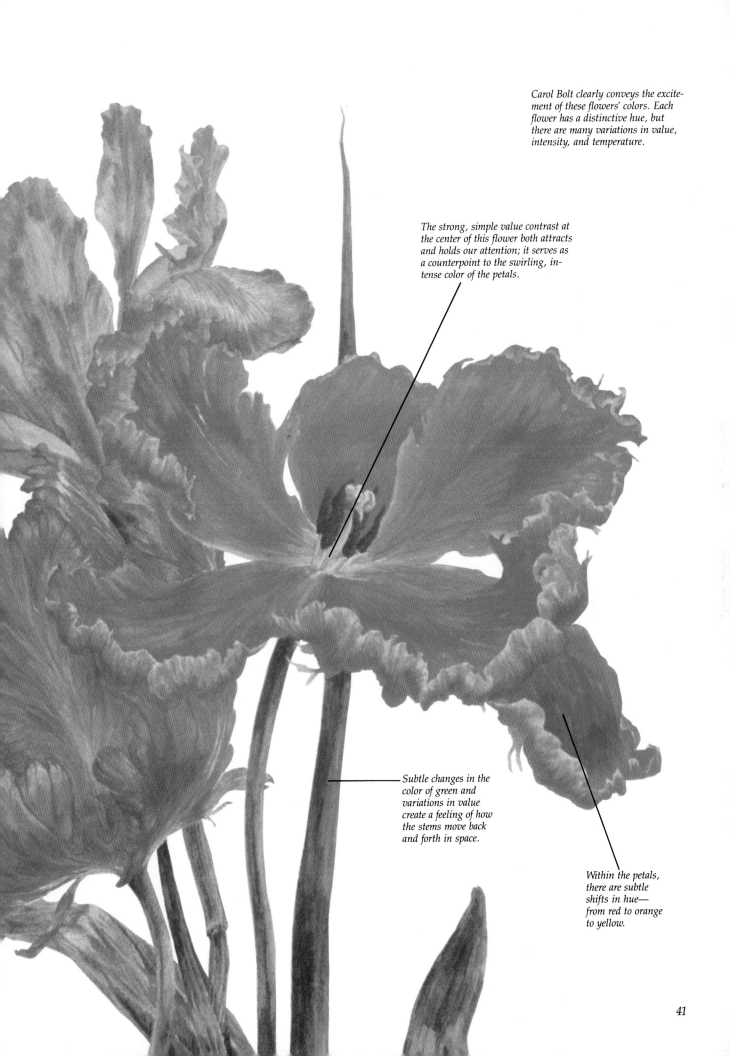

Carol Bolt clearly conveys the excitement of these flowers' colors. Each flower has a distinctive hue, but there are many variations in value, intensity, and temperature.

The strong, simple value contrast at the center of this flower both attracts and holds our attention; it serves as a counterpoint to the swirling, intense color of the petals.

Subtle changes in the color of green and variations in value create a feeling of how the stems move back and forth in space.

Within the petals, there are subtle shifts in hue—from red to orange to yellow.

Creating Variety within Sameness

ONCE you understand the basic characteristics of color, you can create varied, three-dimensional forms even with a limited palette and a fairly unvaried subject. In both paintings here, Nancy Martin uses only a handful of hues and clusters of similar flowers to produce lively, decorative works.

In *Cosmos*, the fernlike shapes that fill the background evolved from Martin's explorations of batik, which taught her the importance of strong design and light and dark contrasts. She began by spattering the background with dark green paint and then added touches of cerulean blue mixed with white to create a fernlike effect. When the cool bluish-green background was completed, she started to paint the foreground foliage and flowers, using a complementary green and red color scheme.

Although the flowers are all the same basic red hue, they vary in both value and size. Some of the colors and shapes repeat, but no two flowers are exactly alike.

EXERCISE 1
When you separate the flowers in Martin's painting, you can see that there's a distinct value range, from almost pure white to deep red.

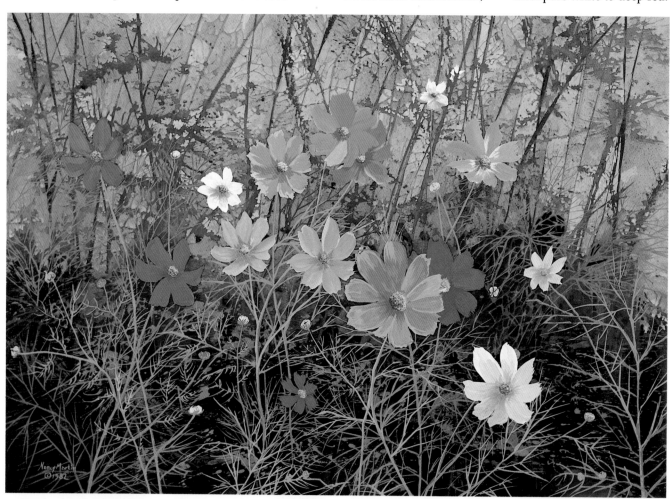

*Nancy Martin, **Cosmos,** 1982, casein on illustration board, 20⅛″ × 29″ (51.1 × 73.7 cm), photo by Rick Jones of Sterling Image Photography, Glenwood Springs, Colorado.*

To understand how shifts in value can create a feeling of variety, take a simple flower and paint it in a range of values, from light to dark, using the same basic hue. Paint the flower in different sizes as well as different values, but keep it in the same position and don't go into too much detail. After you have painted about ten flowers, cut them out and experiment moving them about on a dark piece of paper. Try to find an arrangement that sets up a lively overall pattern.

COLOR AND SHAPE

To set the stage for the bright yellow tulips, Martin first laid in a cool, fairly flat, translucent background made up of medium Thalo green and burnt sienna; because this background is cool and dark, it tends to recede visually. Next Martin brushed in the shapes of leaves and started to establish the flowers.

By choosing a cluster of the same type of flowers, Martin set up a challenge: how could she keep the flowers from becoming boring and repetitive? What intrigued Martin was how the flowers' various stages of openness resembled a chorus singing. Certainly, the six apricot-colored flowers strike a different color note. But most important is the way she manipulated value and intensity within the yellow tulips to give each flower an individual three-dimensional form and to create the feeling of many different voices singing together.

EXERCISE 2

Essentially the yellow tulips are made up of titanium white, cadmium yellow light, cadmium yellow medium, and yellow ocher, with burnt sienna and burnt umber defining the dark centers. Notice, however, how Martin has used different brushstrokes, as well as strong highlights and spots of bright color, to articulate each

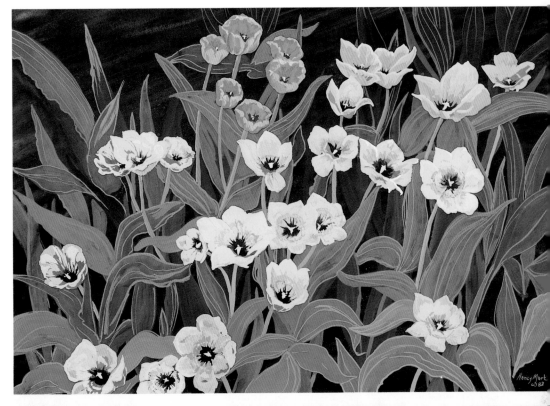

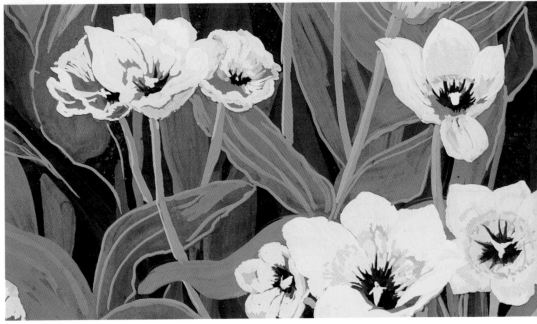

flower's unique shape.

Working with yellow, white, yellow ocher, and burnt umber, paint a similar variety of three-dimensional forms. Choose a simple flower, such as a tulip or a daisy, and use light and dark contrasts to define the form. Then move the flower to a slightly different position

and paint it again. Keep the size the same for this exercise, and concentrate on using variations in value and intensity to articulate different shapes. As before, after you have completed about ten flower studies, cut the forms out and arrange them in different ways on paper.

Nancy Martin,
A Joyful Chorus,
1983, casein on illustration board,
19½" × 28½" (49.5 × 72.4 cm),
photo by Rick Jones
of Sterling Image Photography,
Glenwood Springs, Colorado.

Exploring Your Palette

*P*AINTING FLOWERS, your palette is bound to be different from that favored by artists who mostly paint landscapes or the human figure. If you are just beginning to explore the world of floral painting, you'll soon discover that just one or two earthtones are all that you need. You'll also find yourself experimenting with more reds, roses, violets, blues, and yellows than you may have ever imagined before.

Don't get carried away, though. The simplest palette is often the one that produces the most sophisticated results. Being thoroughly familiar with your colors and understanding how they mix together can be much more important than having an impressive array of thirty or forty hues. Start small when you are beginning to learn the way your medium works. Once you are comfortable working with a basic palette, add other colors to it. At first, try working with just two or three reds, yellows, and blues. Add one green, a violet, a few earthtones, and perhaps a gray.

Set aside some time to become acquainted with how the colors in your palette mix. The following exercise will get you started. Keep in mind that when you are painting flowers, nothing is worse than dull, muddy color. To prevent this, never mix more than three colors together at a time. For watercolorists, this is especially important, particularly when a relatively opaque color like yellow ocher is used.

EXERCISE

To explore the range of color mixtures, use a sheet of paper or a small canvas board for every color in your palette. If your palette consists of twelve colors, you will be painting twelve swatches of color on twelve supports. Take one support and one color and paint twelve rectangles. Then, in eleven of the rectangles, mix in a bit of every color that you work with, one to each rectangle. Leave one rectangle alone— you need it to remind you of qualities of the pure, unadulterated hue.

Follow this procedure for every color, label the results, and keep the boards as a reference tool. Some combinations will seem obvious to you—alizarin crimson and ultramarine, for example. But unless you experiment, you may never discover the strong, cool hue that results from mixing ultramarine and burnt sienna.

The process just described provides an overview, but there are many possible mixtures. Working with two hues, for example, you can change the color by varying the quantity of each pigment. Paint four or five swatches of a color, then add increasing amounts of one other color. If you start with swatches of alizarin crimson, add just a touch of ultramarine to one rectangle, twice as much to the second, three times as much to the third, and so on. Again, label what you have done and keep the color boards close at hand so that you can refer to them as you work.

Cadmium Yellow Light

+ French Ultramarine

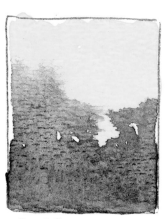

+ Payne's Gray

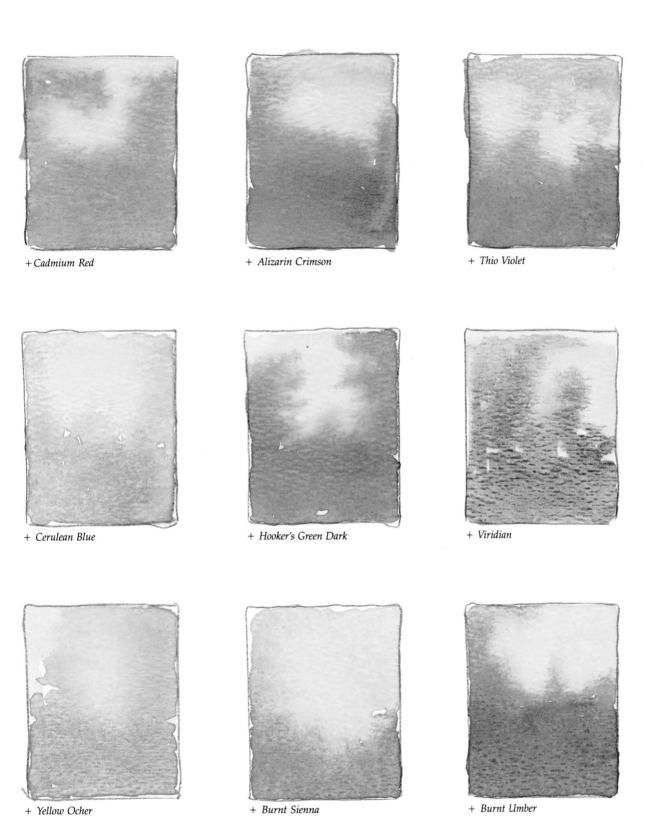

+ Cadmium Red

+ Alizarin Crimson

+ Thio Violet

+ Cerulean Blue

+ Hooker's Green Dark

+ Viridian

+ Yellow Ocher

+ Burnt Sienna

+ Burnt Umber

Composing with Color

LOOKING AT Michael McCloskey's watercolors can help you discover how to compose with color. Pay attention to the different shapes of color and how all the patches of color work together as a whole. Notice where color is used to articulate the form and where it functions more abstractly, providing a needed visual balance. The white of the paper is important, both as a color in the overall design and as a "breathing space" that sets off the vibrancy of different hues.

McCloskey usually begins by working directly from nature. In *Bunch of Gladiolus* he drew the various shapes he saw until they took on the character of the flowers. Then, working quickly, he would wet a shape with clear water and drop in color when the paper had dried to a certain point. While one shape was drying, McCloskey skipped to another area, creating a framework of colored shapes all over the painting.

Experience has taught McCloskey how much the color will spread when it is applied to the damp paper. If you work in watercolor, experiment with this technique. Drop color into small areas at different points in the drying process—when the paper is quite wet, moist, and almost dry. With practice, you will learn how the color diffuses in different situations and how to control this in your painting.

As McCloskey works, each touch of color changes the painting. Although he begins realistically, as the painting evolves, his choices are dictated more and more by what the painting needs. One dot of color suggests another dot of color, in another place. Eventually something "pops" in McCloskey's head, and he knows that he is finished—even if all the shapes are not filled in. What is left unstated can be just as important as what is clearly defined.

EXERCISE
Gather together a bouquet of flowers made up of blossoms of different colors. Carefully sketch it. Now, working all over the support, start to lay in patches of color. Look for the points of most intense color first and use these areas to give shape to the flowers. If you work in watercolor, you can let the color spread, as McCloskey does, but don't try to model the form. Keep the patches of color separate at first, with areas of white space in between.

Continue working back and forth across your support, slowly building a patchwork of color. Once you have the basic framework down, step back and consider what you need to do to pull the different patches of color together into a unified work. You can overlap colors or create transitions with different values, but avoid actually blending the colors with your brush. You may want to leave some areas white—to give your colors "room." Aim for a finished work in which each touch of color is readable, but all the touches weave together visually.

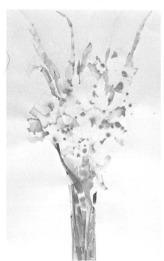

Michael McCloskey,
Bunch of Gladiolus,
1982, watercolor on paper,
35" × 23¼" (88.9 × 60.3 cm),
collection of the artist.

Michael McCloskey, **Hollyhocks,**
1982, watercolor on paper,
38" × 28" (96.5 × 71.1 cm),
collection of Jody and Harrison Tao.

Mixing for Spontaneity

*Jean Shadrach, **Azalea Tree,** 1983, acrylic on canvas, 24" × 36" (61 × 91.4 cm), private collection.*

*Jean Shadrach, **Daisies,** 1984, acrylic on canvas, 18" × 24" (45.7 × 61 cm), collection of Tom and Tennys Owens.*

*T*HERE ARE several methods of mixing color, and each has a slightly different visual effect. You can blend the colors together on your palette or, working wet, you can let them intermingle on your support. You can also let color mix optically: the eye tends to combine small bits of adjacent color so that dots of blue and yellow, for example, are perceived as green. This kind of mixing can have a scintillating quality, for the colors are—in a sense—moving in the viewer's eye.

Jean Shadrach often mixes touches of her acrylic colors directly on the canvas. She may pull one color over another or lay in several colors at once. In doing this, she doesn't blend the colors thoroughly. Instead, if you look closely at a lavender area, you may see streaks of different purples, with varying amounts of red, blue, and white. This incomplete mixing lends the painting an air of spontaneity, as if it were being painted before our eyes.

Shadrach's "spontaneous" mixing, however, is based on full knowledge of her palette. Before she begins to paint, she takes all the colors that she will be using and experiments, combining them quickly in as many ways as possible. She then tacks this practice sheet up in her studio and refers to it while she works.

To tone her canvas, Shadrach first does an underpainting in soft yellow or gold, using a mixture of gesso and cadmium yellow or yellow ocher. She next quickly brushes in the overall pattern of darks and lights, then lays in color with a large painting knife or brush, working dark to light and warm to cool. Both the light-dark contrast and the push and pull between warm and cool give a sense of space and visual movement to the final work.

Jean Shadrach, **Spring,** 1983, acrylic on canvas, 12″ × 24″ (30.5 × 61 cm), collection of the artist.

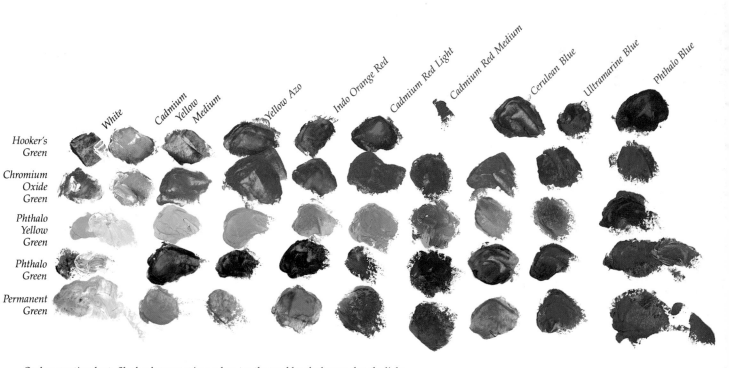

On her practice sheet, Shadrach never mixes colors too thoroughly; she knows that the light-struck effect she is after relies on letting colors blend optically as well as physically.

Discovering Color Interactions

ONE OF THE most fascinating aspects of color is the way one color changes in relation to another. In a painting a color doesn't exist in isolation; it's always interacting visually with the other colors you put down. It isn't enough just to mix the "right" color; you must understand what will happen when you juxtapose other colors. A bright red, for example, may lose its impact if it is repeated throughout a painting or if it is surrounded by a variety of equally bright colors.

There are many, many different ways of using color relationships in a painting, and just a few are touched on here. Instead of modeling a flower, for example, you might use the back-and-forth play of warm and cool yellows to create a feeling of three-dimensional form. To unify a bouquet of disparate flowers, you might establish areas of transition, where one color blends into another, or pick up spots of reflected color to lead the viewer's eye from one point to another. If a patch of bright red-orange seems to pop out of your painting, you can blend it in by making the surrounding colors warmer. The more you understand about color relationships, the easier it will be to achieve the effect you want in your paintings.

COMPLEMENTARY COLORS

Learning about the use of complementary colors is critical to understanding color interactions. Every artist is familiar with the three primary colors—red, yellow, and blue—and with the secondary colors—violet, orange, and green. Colors that are opposite one another on the color wheel are said to be complementary. Red and green are complementary

colors, and so are yellow and violet, and blue and orange. Mixed together, two complementary colors produce a gray.

Complementary colors can be especially exciting when they appear next to one another. Place a square of red next to a square of green; if the proportions are right, the two colors will "vibrate"— first the red will jump forward, then the green. Small passages of green in a mostly red painting can make the reds appear more lively and more brilliant. In other words, by carefully manipulating complementary colors, you can add energy to your flower paintings. Green leaves placed strategically amidst a predominantly red bouquet can accentuate the warmth and brilliance of the reds. Set yellow daffodils alongside purple crocuses and the yellows may look lighter and more brilliant than they actually are, and the purples darker and richer.

These reactions, however, are not automatic. Variations in size, value, intensity, and warmth or coolness all affect what happens when you juxtapose two complements. Once again, the best way to learn is by experimenting on your own. Also explore other possible uses of complements. Enliven a green that is next to a purple by adding a touch of yellow (the complement of purple) to the green. Or, in painting small details like veins, dull your hue with its complement rather than black or gray. For shadowed areas, try using a dark with traces of the light color's complement.

EXERCISE

Many color theorists—Josef Albers, in particular—recommend that students use colored paper, not paint, as they explore color. Working with colored paper, you need

not spend any time mixing hues. And, perhaps more important, the use of colored paper guarantees that you will be working with *exactly* the same color in exercise after exercise. For your explorations, assemble a collection of colored papers—construction paper, bits of magazines, shopping bags, and whatever else you can find.

First cut out one square of orange, one of violet, and one of green. On each square, place a smaller square of red, then note how the red changes in relation to each of the secondary colors. What happens will, of course, depend on the particular colors you use. Set against the orange, the red may bleed into it so that establishing the exact line where they separate is difficult. Next to the violet, however, the red may be quite clear, appearing stronger and more definite than it does against the orange. Finally, placed against the square of green, the red may vibrate; the two hues are complementary, and the contrast between them creates a pulsating effect.

Now explore different possibilities with the same colors. Change the value, intensity, warmth or coolness, even the size of the color area, and notice how the reactions differ.

Finally, try this challenging exercise: take two different colored backgrounds and try to place a center square on each so that the center square's color appears to be the same despite the different backgrounds. If, for example, you choose a red and a green background, you can't simply place two swatches of the same purple in the centers and expect them to look the same. Instead, you have to find two different colors, which *visually* appear to be the same color against the red or green.

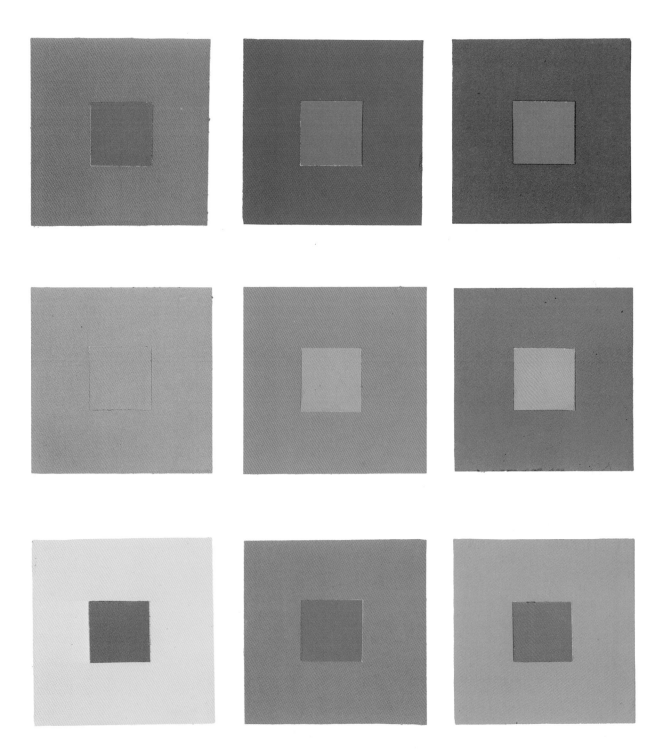

Weaving a Tapestry of Color

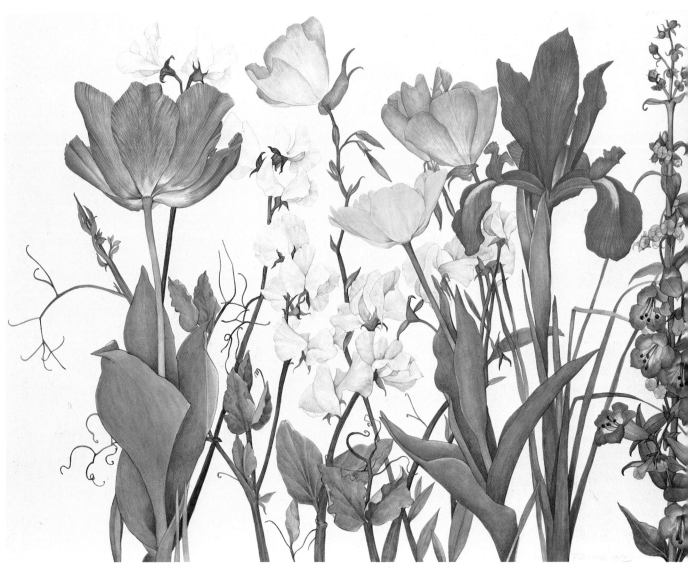

Pamela Glasscock,
Garden Flowers,
1982, watercolor on paper,
22½″ × 30″ (57.2 × 76.2 cm),
collection of Mary McClean,
photo by D. James Dee.

COLOR AND its relationships present a special challenge to artists who paint flowers. So many colors are involved in a single blossom—and many, many more in a bouquet—that it can become difficult to control all the hues and to tie them together.

Pamela Glasscock's painting is carefully designed with an eye to color, shape, and overall pattern. Working from early spring to late summer, she combined flowers that blossom in different seasons—painting each flower from life but composing her painting on the paper. She didn't just paint what she saw; instead, she altered the flowers' relative sizes and adjusted colors to make the painting work as a whole.

Each flower here retains its distinctive coloring, but there are many subtle echoes and repetitions that lead the eye around the painting and weave the colors together. The most obvious connection is between the strong red flowers at either side of the painting. At the same time the intense yellow in the middle attracts attention, creating visual tension. Notice how touches of yellow occur at the base of the pink flowers, and how the stem of the yellow flower is tinged with red. Bits of yellow also break up the purple of the iris—which provides a strong complementary contrast. The purple color in turn is woven into the red and pink flowers, as well as the white blossoms. Look, too, at the stems and leaves, and observe how the gray-greens move more toward red, yellow, or purple to resonate with the flowers.

All these different color notes make this painting dynamic. Instead of focusing on each flower separately, in isolation, we are constantly invited to make comparisons. And these connections help to unify what we see.

EXERCISE 1

Within these white flowers, you can see a lot of subtle color. There are touches of yellow and lavender, as well as warm and cool grays. Although the outlines of the petals are clearly drawn with a brush, the delicate color variations are important in giving the blossoms a solid, three-dimensional form, in keeping with the rest of the painting.

To explore the range of white colors, assemble a bouquet made up totally of white flowers. Even as you arrange them you will be conscious of the slight shifts in color that separate one white flower from the next. When you begin to paint, concentrate on the subtle hints of color that distinguish the flowers. Some may be tinged with blue; others with red. Some may have a decidedly yellow cast; others may be a gray-purple. Use these variations in color to pull one flower away from the next and to articulate the flowers' three-dimensional form.

EXERCISE 2

To achieve the rich, luminous color of this iris, Glasscock built the color up slowly, layer by layer, using very small brushstrokes. Whether you work in watercolor, oil, acrylic, or pastel, you can experiment with layering color to achieve the vibrant hues of flowers. The actual technique, of course, will differ, depending on your medium.

Don't paint a specific subject at first. Instead, explore the layering process itself. Try, for instance, to vary your layers or glazes so that you don't use the same hue over and over again. Experiment with shifting the hue slightly in different layers. If you work in watercolor, you might start with a thin wash made of equal parts of blue and red, then slowly increase the amount of red in subsequent washes. Compare this with what happens when you increase the blue. Now try to use this knowledge in creating the warm and cool purples of an iris.

Surrounding Flowers with Color

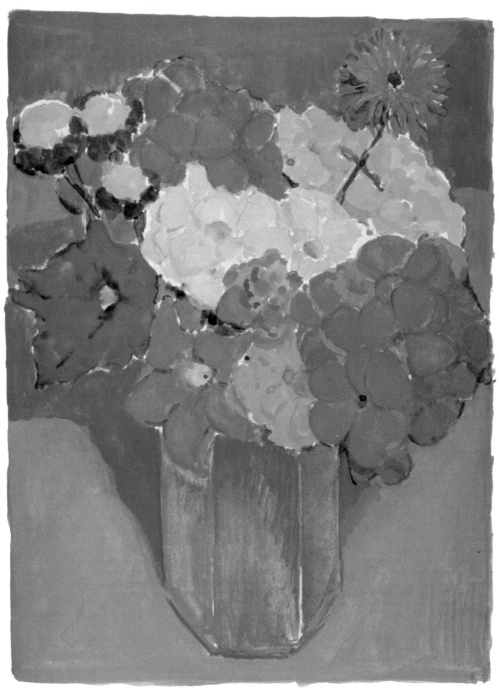

Above and facing page:
Karen Segal,
Summer Bouquet Series,
1981–82, gouache on paper,
10″ × 8″ each (25.4 × 20.3 cm),
photos by David Segal.

*T*HERE ARE many different ways to use color in a painting. For some artists, color is primarily descriptive, giving an individual identity to the various things in a painting. Other artists may focus on value, creating an illusion of three-dimensional form through their use of lights and darks. But it is also possible to use color as *color*—without strong value differences—to provide the major excitement in a painting.

When you look at these small gouache paintings by Karen Segal, the most strik-ing element is the color. In many ways, color is the subject—the flowers provide the starting point, or inspiration, for exploring the visual impact of intense color.

The color that surrounds the bouquet of flowers in each painting is essential to the overall effect. It is not really a "background" color. Try to imagine each of these bouquets set against the white of the paper. Although the colors of the flowers would still be brilliant, much of the tension of the painting would be lost. In each case, the surrounding color inter-acts with the colors of the flowers to increase their aliveness.

EXERCISE
Using several colorful mixed bouquets, like the ones Segal has chosen, do a series of paintings with different sur-rounding colors. Don't rely on your imagination—in-stead, select colored fabric and arrange the flowers against it. Also, for this exer-cise, try using an opaque medium like gouache so you can easily create areas of solid, nontransparent color and so you can correct a color if it doesn't seem right.

Begin by laying in all the main colors fairly quickly and covering the white of your paper or canvas. Then, as you continue to paint, work back and forth between the flowers and the sur-rounding color. Each time you add or adjust a color, notice how it affects all the other colors. But don't fuss over any one painting. Work rapidly and boldly, brushing in relatively large areas of color without too much de-tail. And don't be afraid of "failure." Sometimes you can learn even more by finding out what doesn't work than by getting everything "right." The important thing is to be willing to take risks and to experiment.

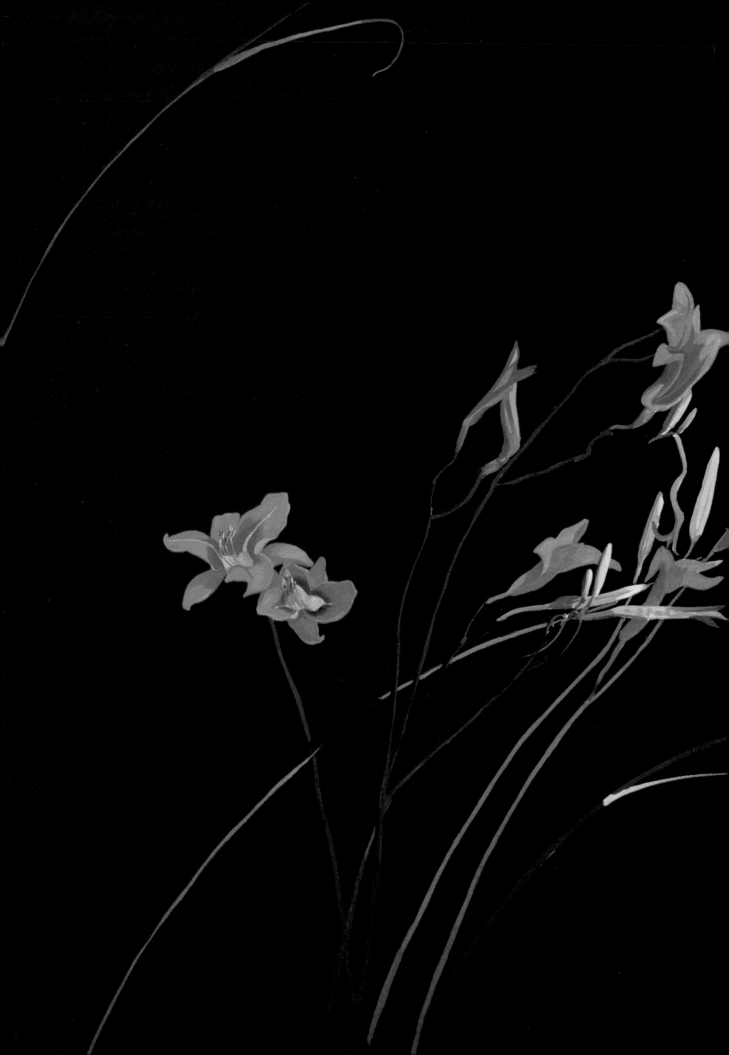

COMPOSING YOUR PAINTINGS

GIVE TWENTY artists identical flowers and identical vases—no doubt you'll end up with twenty very different paintings. Some artists will swoop in on one flower; others will paint the whole bouquet. Some will choose to center the subject; others will play with asymmetry. Some will view the flowers from above; others will render them head on. Some will surround the flowers with stark white space; others will use—or invent—richly patterned backdrops. No two paintings will be alike.

Technically the term *composition* refers to the arrangement of all the pictorial elements— lines, shapes, colors, values, and everything else that makes a painting a painting. So many different factors are at play that it sometimes becomes difficult to think of composition as a whole.

The way you compose a painting hinges on how you see the world. It is your unique point of view that will determine how you balance different pictorial elements and that will make your paintings your own. The best way to discover the compositional modes that work for you is to experiment with a number of approaches. Don't limit yourself to approaches that are comfortable; try to challenge yourself. When you struggle with something extremely difficult, the result can be magically exciting.

Compared with other subject matter, flowers give you incredible compositional freedom. You can pick or buy whatever suits your mood and arrange the flowers as you like. Touching the flowers that you work with, smelling them, moving them about in a vase—all these experiences bring you closer to what you paint.

Gilbert Lewis,
Wood Lily,
1981, gouache on paper,
27½" × 19¾" (69.9 × 50.2 cm).

Choosing a Format and Viewpoint

ONE OF your first compositional decisions involves the size and shape of your support. If your paper or canvas is too small, your brushstrokes may become tight and studied. If the support is too large, your subject may appear lost. But exceptions abound. Flowers are intimate; at times, rendering them on a small canvas may be the best way to emphasize this quality. Large, almost heroic-size canvases can be effective, too, if your aim is to dramatize what you see or to give small anatomical details power.

If you are just starting to paint flowers, select a medium-size support. A 12 × 16-inch sheet of paper or canvas is a good choice. Once you are surer of yourself and where your paintings are going, branch out and experiment with smaller and larger supports. If you are accustomed to making small-scale sketches and paintings and have trouble working with even a medium-size support, spend some time drawing on inexpensive newsprint. Sketch a simple still life quickly and boldly so that your drawing fully occupies the paper.

How should you orient your support? Just because a particular flower is tall and stately, you don't have to use a vertical format. Try painting tulips, hollyhocks, irises, gladioli, and other tall blossoms on supports positioned horizontally. Use preliminary sketches to decide on the best dimensions for the effect you want.

USING A VIEWFINDER

In addition to choosing the size and shape of your support, you must determine how to frame your composition. Using a viewfinder can help you visualize the different compositional options.

Viewfinders are easy to make. First figure out the dimensions of the paper on which you usually work. If your support is 11 × 14 inches, draw a rectangle that is 2¾ × 3½ inches on a piece of heavy cardboard. (This divides the initial dimensions by 4: 11 fourths of an inch equals 2¾ inches; 14 fourths of an inch equals 3½ inches. Use the same formula for any format you use.) Now cut the rectangle out using an x-acto knife or scissors.

To find out how a viewfinder can help you, set up a vase filled with flowers, then look at it through the viewfinder. First frame the overall composition. Next move in closer on a particular detail that you like. Try, too, to look at parts of objects; let the edge of the viewfinder slice a vase in half and see if the composition that results is more exciting than one placed dead center.

Don't just look at your subject horizontally; turn the viewfinder upright and work with it in a vertical format, too. Step forward and backward yourself; study the vases and flowers up close, then from a distance. Using a viewfinder can save you considerable preliminary work. The rough sketches shown on the facing page illustrate some of the many options you can discover when you look at a vase of flowers through a viewfinder.

EXERCISE

Experiment with different formats and different viewpoints. Begin by arranging a few flowers in a vase. Don't make the arrangement too tall or too squat—use a rounded vase and choose flowers that are about twice as long as the height of the vase. Now draw the composition on a rectangular support that has been positioned vertically. Working with the same subject, next sketch the flowers on an identical support that has been placed horizontally. Try varying the placement of the arrangement, too, on both vertical and horizontal fields. Place the vase in the center of the paper, to one side of it, and close to the bottom.

So far this exercise may seem similar to using a viewfinder, but now take a different approach. Look at each drawing separately and decide what adjustments you might make so the composition is more interesting. Using tracing paper, work over your initial drawing. You might exaggerate the shape of a flower to lead the viewer's eye in a particular direction or accentuate the roundness of the vase to create a greater feeling of fullness. You can even eliminate flowers in your bouquet or add an isolated flower, outside the vase, for balance. Try, however, to keep the basic arrangement the same. The idea is not to create a new setup, but to explore how you can retranslate what you see to fit the needs of your drawing.

Accentuating a Vertical Format

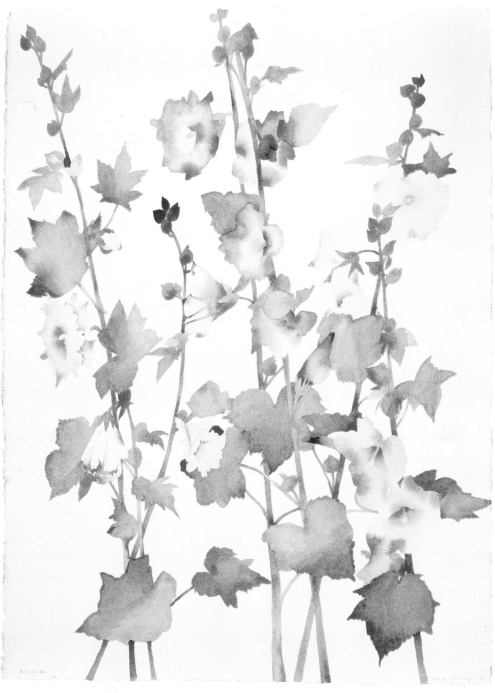

TALL FLOWERS like these hollyhocks and gladioli are so well suited to vertical formats that the skill that underlies these two paintings may not be obvious at first. Both paintings, however, are carefully planned to generate visual excitement.

Pamela Glasscock presents the gladioli frontally in a formal arrangement so that they seem almost like columns repeating across the paper. Yet the effect is far from boring. The tall gladioli stop just short of the top and sides of the paper, invoking visual tension. The white flowers in the center draw the eye inward, while the richly colored flowers on either side pull the eye forward and back and to the sides. Notice, too, how the V-shaped spaces in between the flowers and the stalks direct attention up and down, giving a feeling of both expansion and compression.

Despite the more casual feeling of Susan Headley Van Campen's *Hollyhocks*, her composition is also very carefully balanced. As the flower stalks sweep upward toward the center, they suggest a steadying triangular shape. The tip of the tallest stalk extends beyond the edge of the paper, making the flowers seem taller than they actually are and adding another spark of visual excitement. To balance the strong verticals, loose, arching horizontal lines are set up by the leaves and flowers. Overall, these different directional lines keep the eye moving through the work.

Susan Headley Van Campen,
Hollyhocks,
1983, watercolor on paper,
30" × 22" (76.2 × 55.9 cm),
private collection.

Pamela Glasscock,
Gladioli,
1983, watercolor on paper,
18" × 13" (45.7 × 33 cm),
collection of Susan Smith,
photo by D. James Dee.

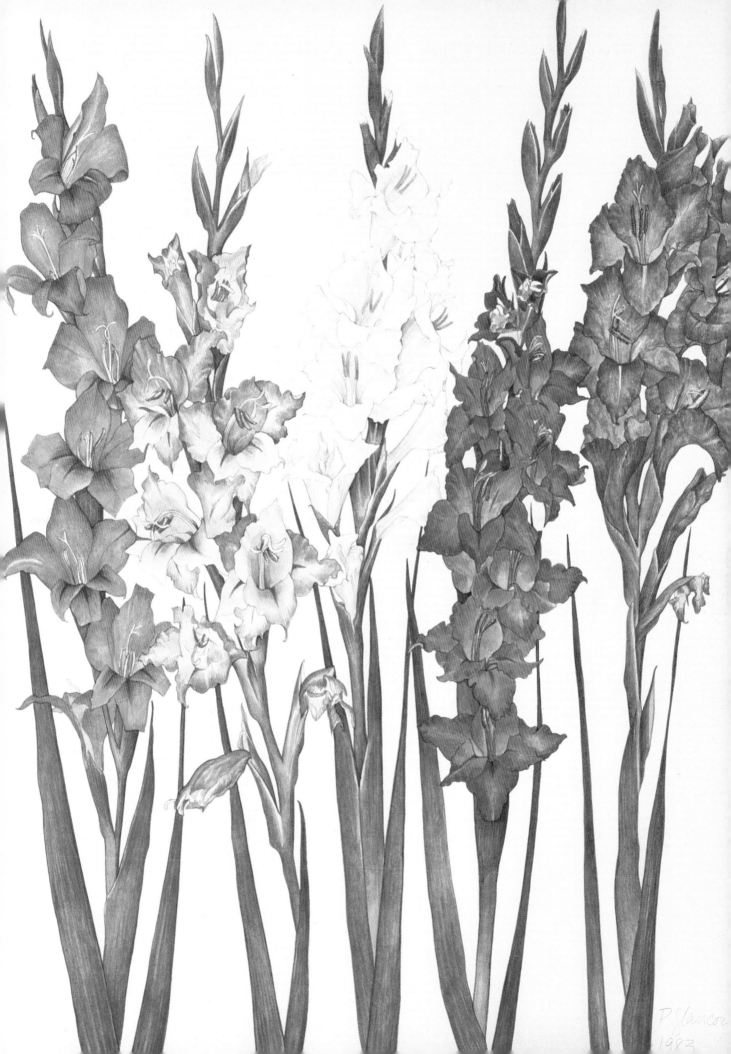

Placing Tall Flowers in a Horizontal Format

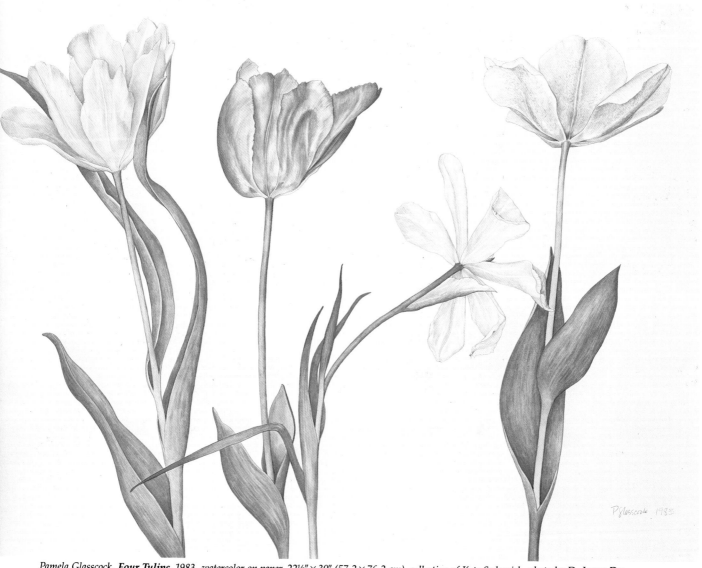

Pamela Glasscock, **Four Tulips**, 1983, watercolor on paper, 22½″ × 30″ (57.2 × 76.2 cm), collection of Kate Sedgwick, photo by D. James Dee.

*L*IKE hollyhocks and glad-ioli, tulips are tall flowers, perfectly suited to a vertical format. As these two water-colors illustrate, though, placing them in a horizontal format can be challenging.

Pamela Glasscock deliber-ately uses the strong vertical thrust of the tulips to create visual tension within the horizontal format. You can almost feel the tension be-tween the flowers pushing upward and the top edge of the paper pushing down.

Notice how important the bottom half of the painting is in creating this effect. If you cover over some of the stems with a blank sheet of paper, the energy is lost.

When you study the com-position further, you can see what holds all this tension in place. In addition to the hori-zontal row of flowers, there are two strong diagonals from the top corners of the painting to the bases of the outside flowers. The diagram below the painting shows the balance this establishes.

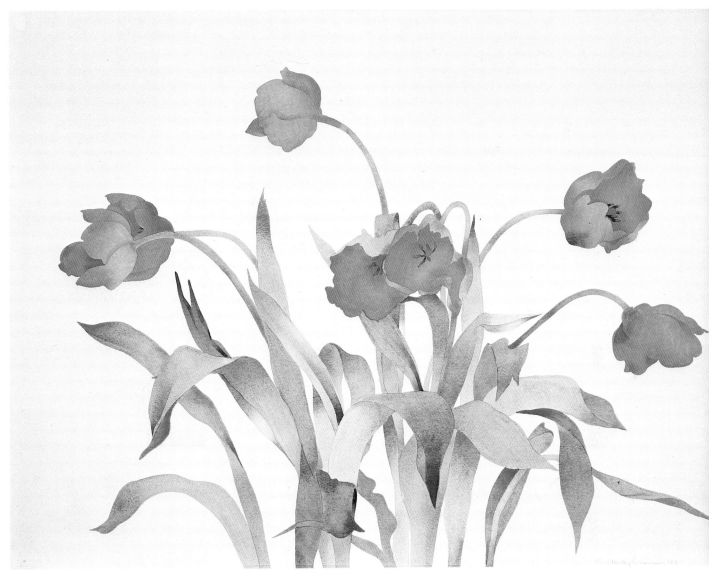

*Susan Headley Van Campen, **Red Tulips,** 1983, watercolor on paper, 22" × 30" (55.9 × 76.2 cm), private collection.*

Susan Headley Van Campen's painting is clearly alive with movement. Note how the two tulips in the center of the composition nod together toward the middle of the paper, while the other five arch outward toward its edges. Here foliage is as important as the flowers. Like the flowers, the leaves have been arranged to enliven the space that surrounds them. They sway to the left and the right, helping to break up what could become a tedious expanse of white. The areas of white, however, are an essential part of the painting, for without this the flowers would not have room for their rhythmic dance.

In the small diagram, you can see just how important the foliage is. Seen alone, the red tulips seem to be scattered across the paper in an almost random pattern. The stems and the leaves help to hold the painting together and at the same time contribute a sense of vertical tension within the horizontal format.

Moving in Close

WHEN YOU MOVE in close on your subject, you may discover a new way of looking at what you see. As Susan McKinnon Rasmussen comments, "I find the more closely I look at a flower and try to understand its structure, the better I translate its qualities." She wants those who view her paintings to feel so close to the flowers that they can imagine smelling them.

In *Spring Shadows*, Rasmussen moves in so close to her subject that the flower becomes almost surreal and ab-stract. The fairly flat, dark green background pushes the flower forward, even closer to the viewer. The strong light-dark pattern and sharp edges enhance the feeling of abstractness, even though the flower is portrayed realistically.

Robin Eschner-Camp's view is slightly more distant than Rasmussen's, but she, too, lets the abstract pattern of the flowers almost fill our view. The jagged edges of the petals are clearly defined by darker tones, although the bleeding of color away from the edges softens the contrast. The different shapes all interlock, describing the flowers and creating a complex pattern across the surface. The white space in the corner is important, however. It provides a resting point for the eye and allows us to "step back" from the intricate detail so that we see the flowers' general form.

EXERCISE

Sketch one vase of flowers three or four times, each time moving in slightly closer to your subject. As you move closer, pay attention to where you place the flowers on your support and ask yourself what seems most important. At first you may want to concentrate on the relationships that exist between several flowers. When you are just a few inches away from the subject, the relationships that exist between the petals of one flower may matter most.

Finally, after you have moved in very close to the flowers, move back and view the arrangement from a distance. Based on what you have discovered at an intimate range, ask yourself how your perceptions have changed.

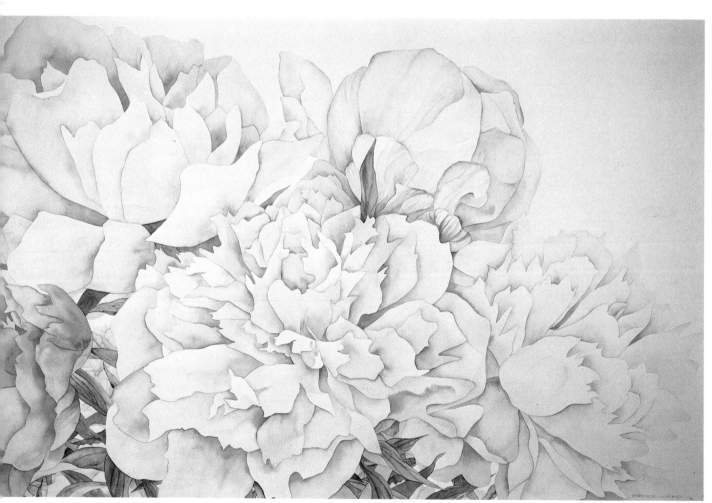

Robin Eschner-Camp,
North Bay Peonies,
1985, watercolor on paper,
26" × 40" (66 × 101.6 cm),
private collection.

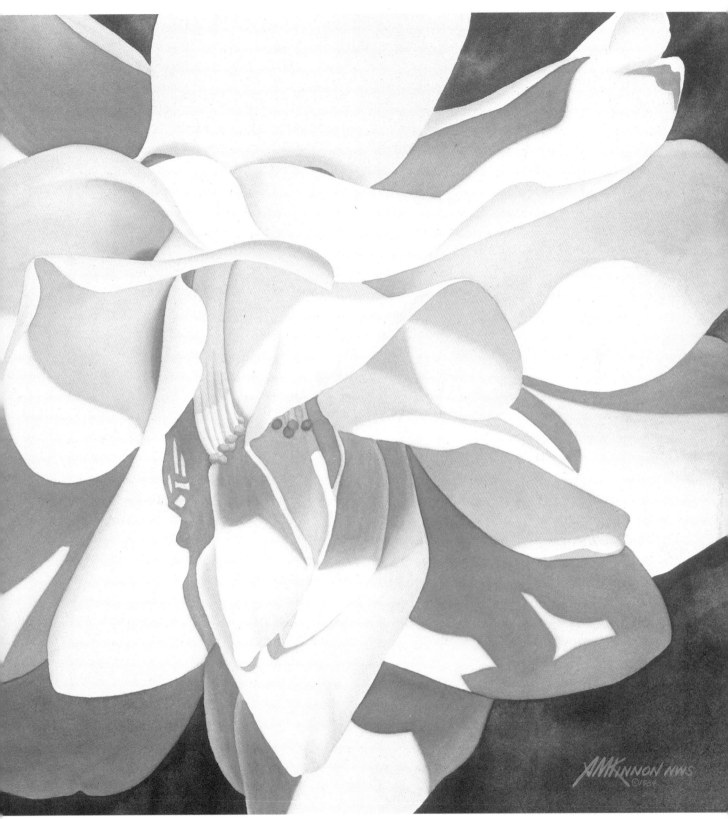

Susan McKinnon Rasmussen,
Spring Shadows,
1984, watercolor on paper,
21¾″ × 21¾″ (57.1 × 57.1 cm),
collection of James Hoover,
photo by Photo Art, Portland, Oregon.

Working with the Edges of Your Support

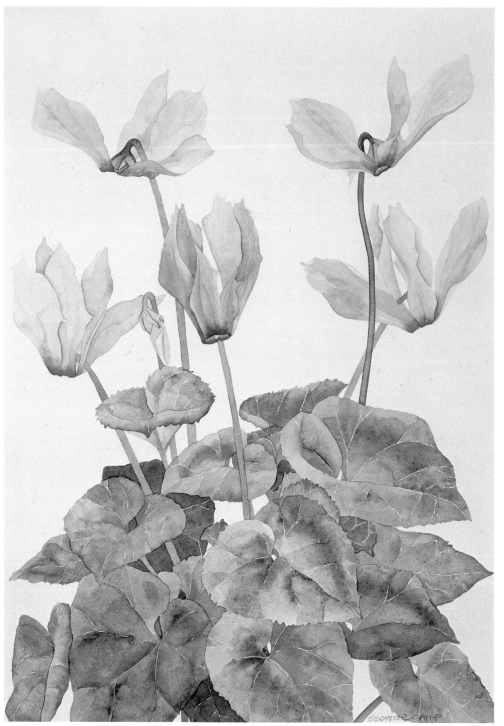

Robin Eschner-Camp,
Cyclamen,
1982, watercolor on paper,
14″×10″ (35.6×25.4 cm).

1

2

3

HOW YOU CROP your subject is just as important as the distance from which you view it. If you look at every setup as a *fait accompli* and are doggedly determined to include every detail, vary your habits. Viewfinders help you become more aware of how your subject relates to the edges of your support, and they make it easy to see new ways of cropping your compositions. Using them, you can experiment with compositions like those you see here.

In both of these paintings, the artists have presented a kind of "slice of life," cropping off part of their subjects. In Robin Eschner-Camp's *Cyclamen*, the flowers are contained within the boundaries of the paper; the leaves extend beyond the bottom of the support, yet never touch the sides. The leaves are dark and relatively heavy—they form a thick mass weighing down the composition. Even the light, pale pink flowers seem pulled into the leaves; their petals float upward almost as if the stems were being sucked down. Because so many elements direct attention to the bottom of the paper, the white space at the top and on the sides becomes critical; the painting needs this white space to breathe and to balance the downward thrust.

To understand how important Eschner-Camp's placement of her subject is, take strips of black paper and block out different portions of the painting, using the reduced illustrations as a guide. (1) If you move in on the sides, the flowers and the leaves seem trapped in too small a space. (2) If you cut off the top, the whole composition sinks to the bottom of the paper. (3) Surprisingly, if you crop the bottom, you lose the weight needed to balance the flowers.

Now look at Gilbert Lewis's *Hydrangea*, where the subject is cut off on the right and at the bottom, generating visual tension. To balance the composition, Lewis has accentuated the two dark green leaves in the upper left corner. The leaves stop just short of the paper's edge, halting the eye, then directing it back into the painting. Again, you might try cropping Lewis's painting in different places to understand more clearly how important the edges he chose are.

EXERCISE
Study some of your old drawings and paintings that you feel were unsuccessful. Ask yourself how your subjects relate to the edges of the support. With black construction paper, "reframe" your subject—blocking out areas along the top, sides, and/or bottom to see if cropping a subject differently will increase the visual tension. Next use construction-paper frames to isolate details; search for paintings within your paintings. Are some of these smaller compositions more exciting than the original? Using what you have discovered, rework one or two of your compositions.

Gilbert Lewis,
Hydrangea,
1980, gouache on paper,
14¾" × 22" (37.5 × 55.9 cm),
private collection.

Designing All the Painting Space

THE BACKGROUND is an integral element of every painting and just as important as the actual subject. Never let it be an afterthought or view it simply as an empty area. Some artists, in fact, prefer not to use the term *background* because they believe that every area in a painting deserves equal consideration.

If you work on a white support, it is especially important that you learn to work with the space *around* the objects you are painting. This space can be as beautiful as the objects you paint, yet it is very often ignored. If you have trouble looking at the white space in your paintings, do a quick sketch in reverse, making all the white areas black and leaving everything else white. Now ask yourself how the black and white areas relate. Is there an interesting division of the space? Or do the "black" areas seem random and accidental?

A good way to forget about details and see the overall design of what you draw is to turn the paper upside down. Looking at it from that point of view it may be easier for you to see dull, flat background areas that need further elaboration. Next, turn the paper upright, examine the areas that aren't working, then try to move your subject about until the background is activated. You may have to add a few more leaves or move the flowers about in the vase. It may even help to cut a few flower stems back so that the flowers aren't lined up in the vase like bowling pins. When you have rearranged the flowers, sketch them again.

USING DRAMATIC DIVISIONS

The bold design of Pamela Glasscock's painting is striking. The strong diagonal of the stem slashes across, slicing the space in two, and its serrated edges augment this thrust. The shorter stem pulls the eye rapidly toward the top, stopping short of the paper's edge to heighten the visual tension. The flower, with its strong color, provides a stabilizing balance.

Glasscock's treatment of the negative space in this painting is just as important as her handling of the plant. If you squint your eyes, or look at the negative of the painting shown here, you can see how the white areas are considered as shapes, activating the space.

EXERCISE

Place strong, bold, black shapes on a sheet of white paper and arrange them so they activate the picture space. To relate this to your flower paintings, first draw a few flowers on black paper, simplifying them as much as possible; draw some leaves and stems, too. After you have cut or torn your designs out, arrange and rearrange them on the white surface. If you have trouble seeing the importance, or weight, of the white paper, reverse this exercise—play with white forms on a piece of black construction paper.

Pamela Glasscock,
Epiphyllum,
1983, watercolor on paper,
18" × 13" (45.7 × 33 cm),
collection of Laurie McGregor,
photo by D. James Dee.

P. Yussovsk 1923

Exploring Tension and Release

Robin Eschner-Camp, **Protea,** 1985,
watercolor on paper, 22" × 30" (55.9 × 76.2 cm),
courtesy of Dubins Gallery, Los Angeles.

*I*N BOTH these paintings by Robin Eschner-Camp, the unpainted areas balance the weighted painted areas. The contrast between the white paper and the delicately painted vases, leaves, and flowers builds visual tension. Yet the white areas also provide an important release, creating a feeling of restful "breathing" space.

In *Protea*, Eschner-Camp sets a simple glass vase filled with a large, lush flower against an expanse of stark white paper. Imagine, if you can, how the painting would look if the subject were moved to the center of the paper. Try cropping it; cover the right side of the composition with a sheet of black paper. The flower itself may still be pleasing, but all the dynamic energy of the painting suddenly vanishes.

Other compositional elements reinforce Eschner-Camp's design. The leaves help balance the asymmetry of the piece. On the far left, one leaf presses slightly upward and toward us; on the right, another presses downward, leading into the surrounding space. These leaves suggest a steadying diagonal axis, which you can see if you draw a line from the upper left corner to the lower right. This line runs through the base of the flower, dividing the composition into two equal triangles. Countering this diagonal line is the sturdy, woody stem of the flower; it provides a strong, stabilizing vertical note.

In *Three, Two, One*, three tulips, two irises, and one rose sit in a glass jar that rests on a small square of pink paper. A light pencil line that runs across the paper behind the jar establishes the horizon. How can such simple elements be so powerful? First, the artist has moved her subject away from the center of the paper, so there is an immediate tension between the subject and the surrounding space. Second, the lines, shapes, and colors of the flowers bring out their different personalities and actively direct the eye around the painting. Finally, the square of pink paper, the faintly indicated horizon line, and the chunky glass jar all help to anchor the flowers, creating a sense of space and weight, and giving the transitory subject—flowers—a feeling of permanence.

Robin Eschner-Camp,
Three, Two, One,
1983, watercolor on paper,
16″×16″ (40.6×40.6 cm),
private collection.

Working with a Black Background

SETTING FLOWERS against a black background can be an exciting way to design space. Black pushes the flowers you paint forward, and makes every detail assume a new importance. Black also tends to flatten out what you paint, which can make you more aware of the decorative impact.

If you work with watercolor, there is an element of risk involved when you plan to set your painting against black. If you render the flowers first, then you must carefully fill in the background. One slip of the brush and you can ruin what you have done. You can, of course, sketch in the flowers and then mask this area before applying a black wash. It may, however, be difficult to achieve a solid black wash, without any variations in value.

You can experiment more easily with gouache. This opaque, water-soluble medium can be laid in on a sheet of black paper so you can instantly see the overall design you are creating. If your preferred medium is oil or acrylics, stain the canvas with a dark-value hue before you begin to paint.

ADDING CONTRAST

In Michael McCloskey's painting, the black background wasn't originally planned. The pinkish-white lilies were so pale, though, that their boundaries merged with the white of the paper. To push them away from the background, McCloskey decided to add the black. Laying it in wasn't easy, however, as the wash had to be uniform in value and uniformly applied or its irregularity would pull attention away from the flowers.

Set against the black, the white vase and ground take on a clear importance. They form a steady vertical and horizontal base for all the activity of the flowers and leaves at the top. Their importance is reinforced by the way McCloskey has cropped the delicate, but energetic, flowers at the top. The viewer's eye is forced down into the vase and ground, and then moves up again into the intricate patterning of the lilies.

The black background definitely enhances the abstract, decorative quality of this painting and gives it an Oriental feeling. Try to imagine the painting without the black to understand how much its contrast contributes to the visual impact.

ACCENTUATING PATTERN

In Susan Headley Van Campen's painting, design is paramount. Focus on how the delicate tracery of the branches, leaves, and flowers weaves across the paper. The pattern formed by the hibiscus holds the composition together so tightly that you can turn the painting in any direction and it still makes sense. Every area of this painting is important—there is no unconsidered space.

EXERCISE

Compose a floral subject that moves all over the surface of the paper. Be very conscious of the quality of line you are using. Don't make your lines too regular or too straight. Try to build up a composition using curving, meandering lines. When you have finished painting the flowers, fill in the background with black pigment, then study how your painting changes.

Michael McCloskey,
Vase of Lilies,
1981, watercolor on paper,
30″ × 22″ (76.2 × 55.9 cm),
collection of Jody and Harrison Tao.

Susan Headley Van Campen, **Hibiscus,** *1981, watercolor on paper, 22″ × 30″ (55.9 × 76.2 cm), private collection.*

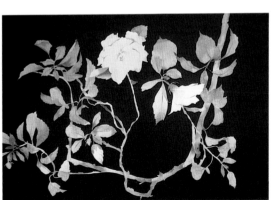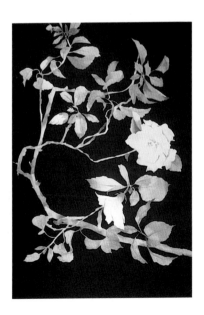

Setting up Compositional Challenges

COMPOSITION isn't an exact science—there are no set rules that will automatically improve your paintings. Analyzing what makes different paintings successful can be deceptive: few artists actually plan every inch of their paintings—the process is usually much more intuitive. By observing the world around them, looking at other artists' paintings, and studying what happens in their own work, most artists have become familiar with a visual language. Instead of thinking out every "sentence" beforehand, they know almost instinctively how to compose whatever they see.

The best way to become fluent in visual language and to hone your compositional skills is to question what you see and to explore as many different ways of looking at the world as possible. The following exercises have been designed to start you on your way. Each presents you with a new challenge.

EXERCISES

1. Jot down compositional ideas in a notebook. Take it with you to museums and keep it at your side when you look at art books or magazines. When you are attracted to a work, or puzzled by one, figure out why you react the way you do. Quickly sketch the basic structure of the piece and ask yourself: Is there a strong horizontal, vertical, or diagonal thrust? What balances the work? How do the shapes and colors relate? Determine what animates a painting and what keeps the eye moving through it.

2. Practice arranging your setup on paper before you start to paint. One way to do this is to use cutouts, as suggested in the exercise on page 68. You can also use tracing paper. First sketch the scene on the translucent paper, then lay the sheet against a clean piece of drawing paper. Study your drawing carefully, looking for areas that you don't like. With scissors, cut off any troublesome areas; then try to reposition the bits that you have cut away. You may find that moving them just a half an inch or so will make them work with the rest of the composition. If that doesn't work, sketch possible alternatives on tracing paper, cut them out, and place them against your original sketch. Once you have figured out exactly how your painting should look, rearrange the setup.

3. Using collage, learn to focus on large shapes and basic colors. Working this way is a perfect antidote for the artist who worries constantly about detail. Experiment with simple construction paper, pieces of Oriental (rice) paper, or even pages pulled from magazines. After you have set up your subject, tear the paper into the appropriate shapes, paste them down, then introduce passages of paint to pull areas together or to emphasize what you feel is important. If you find that you have covered too much of your support, reintroduce white by gluing pieces of paper over what you have already done.

4. Execute a series of paintings based on the same setup. First do three or four quick color studies of the setup seen from different angles. Next try doing the same setup in several different media—gouache, watercolor, and pastel are good choices. You can also explore different painting methods: in one work use loose, bold strokes; in another paint carefully, laying in as much detail as possible. Or try composing a painting using only curved lines; then do one made up entirely of straight lines; finally, don't allow yourself to use any lines at all.

You might also emphasize different aspects of your subject. In one work explore texture; in another concentrate on the underlying geometric structure; in yet another accentuate the pattern of movement. Countless variations of these experiments exist.

5. Choose flowers and containers that you don't think will work together and then try to make them interesting. You might pair baby's breath with birds of paradise, set a delicate orchid inside a sturdy stoneware crock, or group a bunch of black-eyed susans in a cut-glass vase. Looking at flowers in unusual arrangements can trigger new perceptions and a fresh approach to painting.

6. Paint the same flower in different situations—on its own, in a group of similar flowers, and in a mixed bouquet. How do your perceptions of and attitudes toward the flower change with different arrangements? In one situation you may decide to emphasize the flower's line; in another, its color; in another, its overall shape.

7. Compose an imaginary bouquet made up of flowers that blossom at different times of the year. For your models you can use several living flowers, plus an assortment of flowers from photographs or drawings. You can even borrow flowers from any of the paintings in this book. Concentrate on creating an arrangement in which the different flowers seem believable together. To do this, you may need to vary the flowers' proportions slightly or modify their color.

8. Working from a living flower, try to abstract and simplify what you see, as Michael McCloskey does in his painting on page 75. You may find abstraction easier if you choose a flower with a strong, definite shape and simple foliage—tulips and lilies are two possibilities. Spend some time drawing the flower and studying its structure. This will help you to determine which aspects are essential and which details you can leave out.

McCloskey often chooses a head-on view, as in the painting shown here, because this helps him to flatten the image and to give it a decorative, abstract feeling. Instead of copying what he sees, he tries to translate the essence of his experience. Reality serves as a take-off point for his imagination.

Michael McCloskey,
Amaryllis,
1983, watercolor on paper,
30" × 22" (76.2 × 55.9 cm),
private collection.

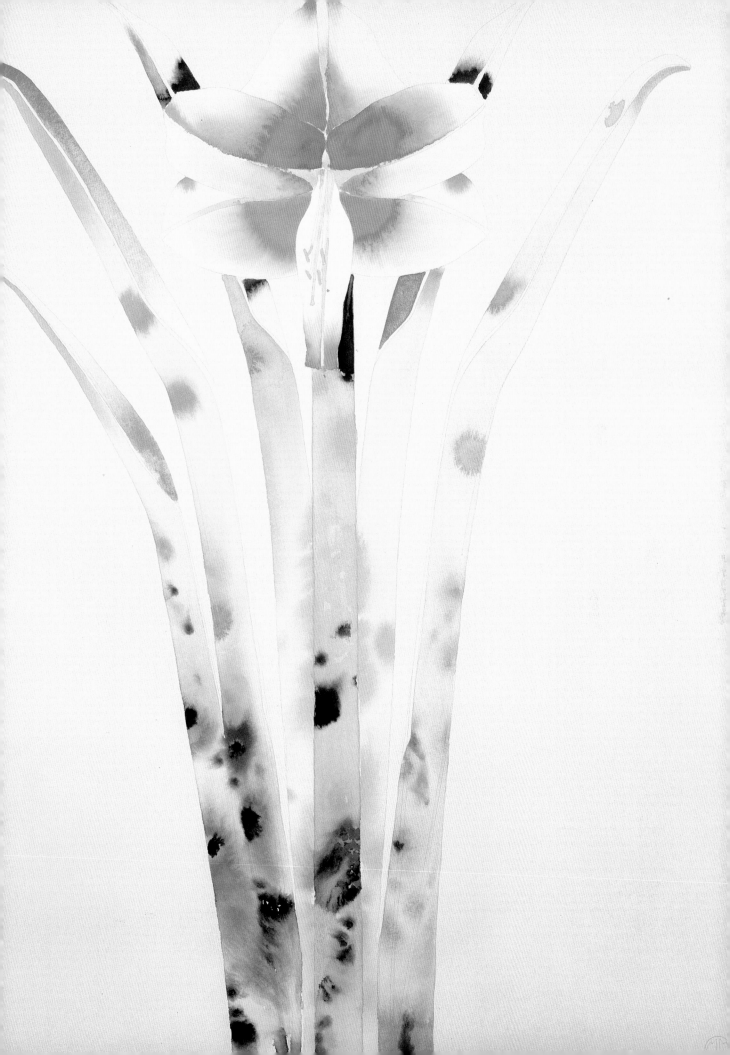

Developing Rhythmic Patterns

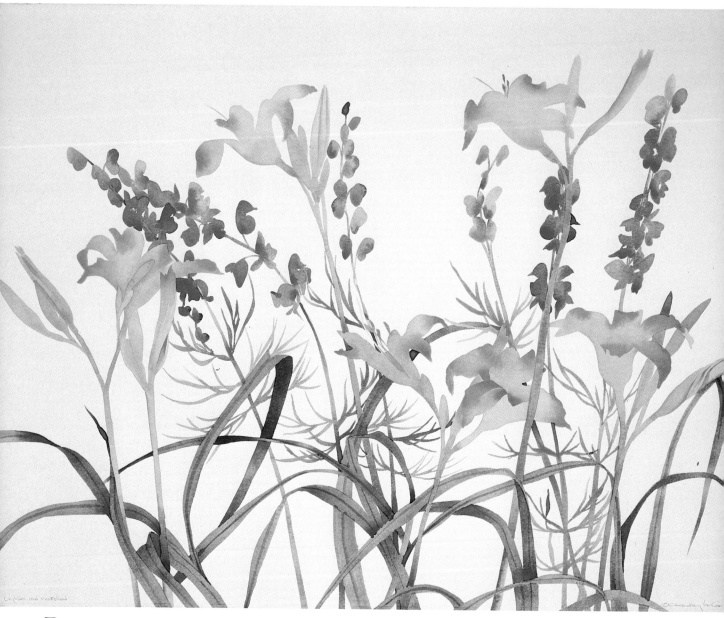

_B_OTH OF these paintings focus on flowers alone and let the flowers fill or almost fill the paper. No distant space exists; the eye stays close to the picture plane, moving about as it follows the dance of the flowers. It is this focus on the rhythmic movement of the flowers that unifies each painting.

Specifically, in Carol Bolt's painting, the flowers and leaves touch and seem to go beyond the paper's edge, both along the sides and at the top. This approach to filling the paper works especially well with flowers that have loose, irregular shapes. To understand the effectiveness of the pattern Bolt has set up, squint your eyes and look at the white areas of the painting—these shapes are exciting, too. Also note how the liveliness of the pattern is enhanced by the tension between the vivid pinks of the flowers and the bold greens of the leaves.

In Susan Headley Van Campen's painting, the orange and purple blossoms form a rough oval that extends across the paper. Below, the foliage weaves in and out, tying the flowers, and the picture, together. The leaves arch in all directions, left and right, up and down, activating the surface. Notice, too, how the flowers sweep up and outward, toward the top and the sides of the paper.

Color plays an important role here as well. The use of near-complements—yellow-orange and blue-purple—sets up a push-pull vibration that energizes the painting. Within the foliage, there are subtle shifts in color and value, which lead the eye in and out of the picture space.

Above:
Susan Headley Van Campen,
Monkshood and Daylilies,
1983, watercolor on paper,
22" × 30" (55.9 × 76.2 cm),
private collection.

Right:
Carol Bolt,
Cyclamen,
watercolor on paper,
16" × 14" (40.6 × 35.6 cm),
private collection.

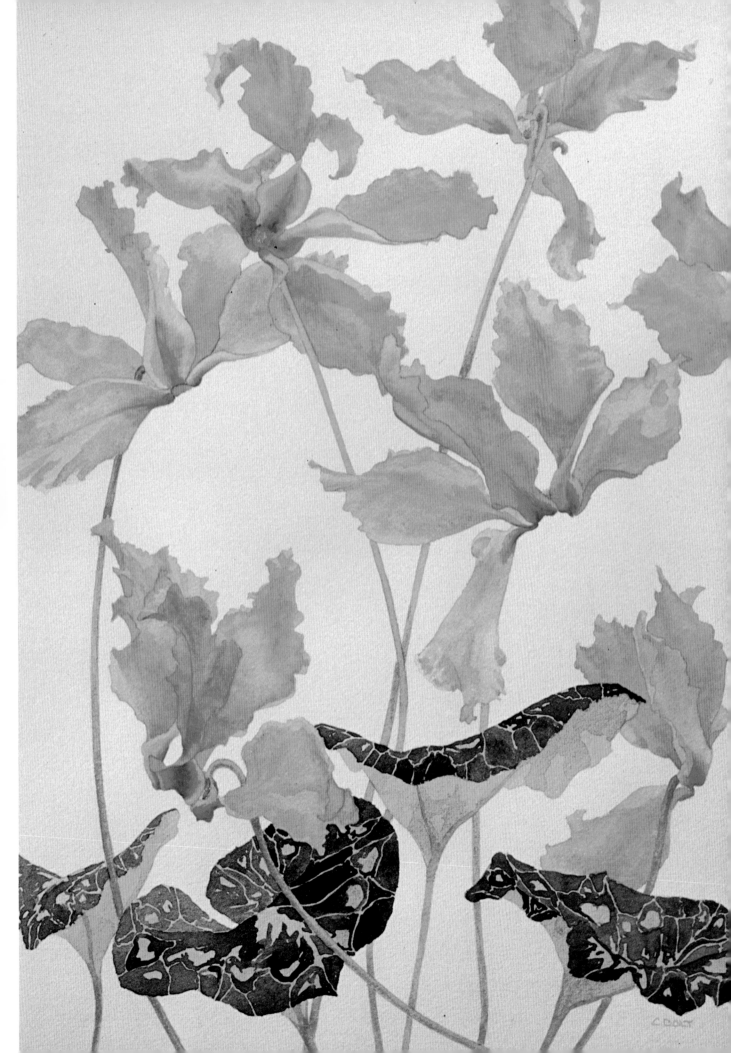

PAINTING STILL LIFES WITH FLOWERS

SETTING UP a still life gives you incredible freedom. You can include whatever you like, arrange the objects as you please, choose how you want them to be lit, and select a backdrop that intrigues you. If you have been painting flowers for some time, you have already created many still lifes. Simply placing flowers in a vase, setting them on a table, then rendering them in paint is, in a simplified form, the work of a still life artist. Adding other objects to your compositions and then learning how to pull everything together can be a fascinating challenge, keeping the art of painting flowers fresh and exciting year after year.

Setting up the still life is, of course, only the starting point. No two artists will paint the same still life in the same way. What matters is what interests *you*. Ask yourself why you want to paint a particular setup. Are you excited by the colors, the personalities of the objects, the overall mood? If you can move away from the idea of painting a "pretty picture," and find something that truly intrigues you, absorbing your attention, this interest is likely to come through in your painting, making it exciting to look at.

Moving from Simple to Complex

THE EXERCISES here are designed to get you started if you have never combined flowers with other still life objects or if you feel unsure about how to arrange things. Even if you are fairly experienced, however, it can be helpful to go back to the beginning and move from a simple arrangement to something more complex.

EXERCISES

1. Although almost any object can be included in a setup, start with a few simple things—in addition to your flowers, an apple, an orange, an ordinary seashell, a pipe, or a pitcher are good choices. Choose objects that have clear profiles. If you are just beginning to paint, it's a good idea to work with a plain, opaque container—a piece of crockery, for example—and with hardy flowers that have strong, definite shapes. Daisies or chrysanthemums are ideal. You want to be able to concentrate on the basic shapes that you see and on how they work together.

In selecting the objects to include in your painting, keep their colors in mind. Try to set up a symphony of related hues—warm yellows, oranges, reds, and earth-tones, for example. But make sure that you include one or two accent notes. It can be boring if everything is too similar—add a dash of deep rust to an arrangement made up mostly of lighter hues, or introduce a rich, purple plum if everything seems yellow and gold.

Place the objects you gather together on a table or a stool against a white wall. You may want to cover the surface of the table or stool with a piece of cloth; work with fabric that is a solid color, not checked, striped, or patterned. Now sketch and paint the scene.

2. Add a few other objects to your first setup, then rearrange what you see. Instead of placing a vase dead center, put it slightly to the left or right.

Position the fruit in front of the vase, then experiment moving it about. Be aware of spatial relations. Study how each object relates to the others. When you are painting still lifes, you are working with relatively shallow space; no vast vistas exist. Minute adjustments—moving an apple or a pear in front of a vase instead of next to it—can result in a totally different effect.

Before you paint, sketch the setup, moving in as close as you can to the subject. Let it fill the entire sheet of paper. Zooming in on what you see can help you spot compositional flaws.

3. In any painting, lighting is critical. The play of light and dark on the vase, fruit, and flowers is as strong a compositional element as the objects themselves. Clear, even light—the kind you get working in front of a window or under a skylight in midday—is fine when you are just starting to paint still lifes. Soon you'll discover that strong, directional light—the kind that illuminates one side of an object and casts the other in shadow—is often (though not always) much more interesting.

Working with inexpensive, clip-on lamps is one of the easiest ways of creating dynamic lighting. Holding the lamp in your hand, try shining the light on your setup from different angles. As you experiment, manipulate the light to create dark shadows. Note how the shadows have an actual physical presence; they can be as important as the objects that you use. Do quick color studies to capture the different lighting effects.

4. Tack a piece of fabric to the wall. Choose one that has a definite pattern. Looking frontally at the composition, rearrange the objects until you have a unified setup. At this point, think through how you will make the flowers and other objects stand out against the patterned backdrop. If you have

chosen a piece of cloth that has decided vertical stripes, you may need to add some horizontal elements to balance your painting. If you are using a very elaborate, decorative fabric you may want to use simple objects with bold profiles that will stand out clearly against the cloth.

5. For a different arrangement, take another approach. Instead of beginning with the flowers, first comb your home for objects that interest you. Try pulling together things that are somehow related. Kitchen bowls, eggs, and an eggbeater work together. So do pens, paper, rulers, and scissors. Search for interesting fabric, too. An old paisley shawl, a brilliantly colored striped scarf, or a checked dish towel can easily key the mood of your painting. If you have trouble deciding which objects to include, look for things that have some personal meaning to you. Just the fact that they are somehow special will make it fun to paint them.

Once you've decided on the objects, start arranging them. Then step back from your setup and ask yourself what kind of flowers might add interest. You may want to select flowers that fit in with the color scheme or enhance an intimate mood. But you can also use flowers to provide a contrasting note, introducing a touch of elegance among everyday objects or adding irregular shapes to a geometric setup. After you choose your flowers, of course, you may need to adjust all the objects to find a composition that you really *want* to paint.

6. Finally, instead of using a flat surface, try to build up a substructure using books. Pile as many as you like on top of the flat surface, then drape them with the fabric you have chosen. You can prop whatever you like up against the covered books, or set objects on top of them. You needn't stick to books, either. Use old pie tins,

boxes, or similar objects.

Another way to establish different levels is to compose your still life not only on a table (or other surface) but on a stool or chair placed in front of the table. Try draping the main surface with fabric—it will serve as the backdrop for the objects you place on the lower surface. You can either drape the lower surface too, or leave it alone.

When you start arranging your still life, you may not know at first what to include and what to leave out. Experience will help you decide the degree of complexity that you find most comfortable. For the time being, err on the side of excess. An elaborate still life is like a piece of sculpture—it can be viewed from many different angles, each one providing new visual information. As you add and subtract objects, move around the setup. Try to see it as a three-dimensional creation, and not as something that can be viewed from only one side.

At some point while you are setting up your still life, an inner gong will go off—suddenly you will realize that nothing else should be added. Pay attention to this instinct and stop. When your setup is complete, try sketching it from several different angles. Don't just move around it—step onto a chair and look down on it, or sit on the floor and look up at it. Move in on portions of the scene, too; elaborate setups often contain dozens of smaller pictures. If you have trouble seeing the parts when you are confronted with the whole, use a viewfinder to frame different bits of the scene.

Elizabeth Osborne,
Amish Quilt with Iris,
1985, oil on canvas,
88" × 65" (223.6 × 152.4 cm),
collection of Sueyun
and George Locks
photo courtesy of Fischbach Gallery,
New York City.

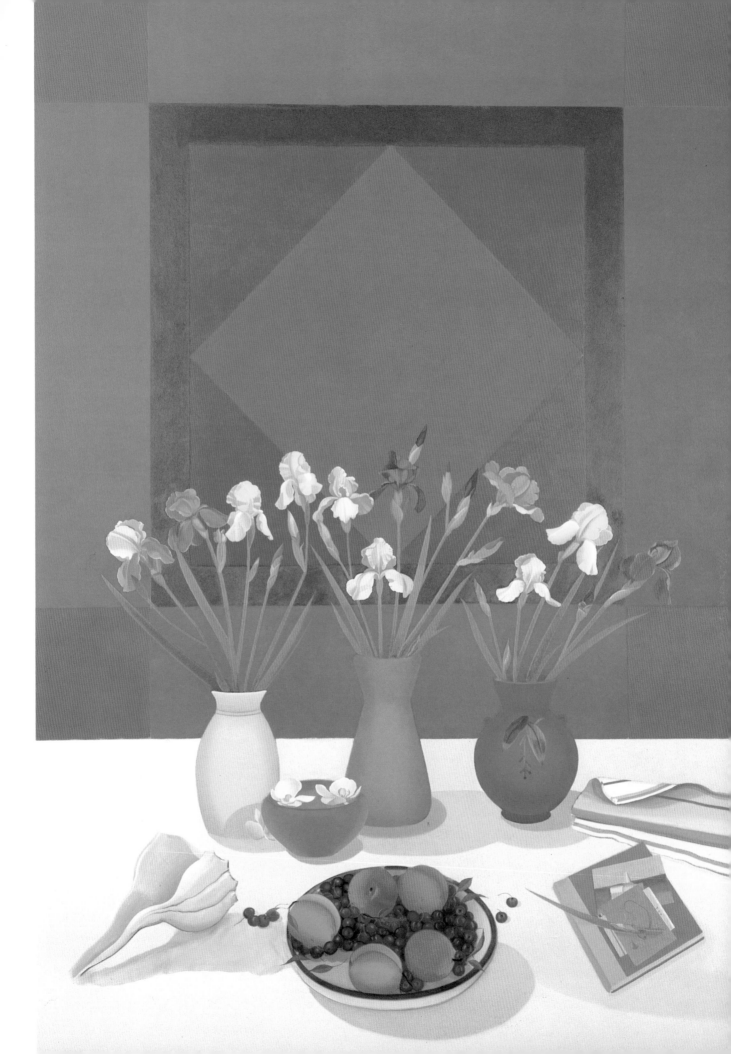

Fostering Simplicity and Directness

*T*HREE VASES, one table, and nine bunches of flowers are the basic elements in these paintings by John Thornton. Their simplicity gives them a timeless feeling; they seem almost like portraits of particular flowers rather than ordinary still lifes. Looking at them, you can also easily see how small adjustments in a setup might change the entire mood of a painting.

From a compositional view, what is striking is that in most of these paintings the vase and the flowers are centrally positioned. Almost invariably artists are warned to avoid centering the subject on the canvas—it's said to create boring paintings. Yet Thornton's works never seem too static. In them, small objects such as shells, cups, scissors, and towels break up what could become too predictable a use of space. At times Thornton also animates the pictorial space by placing the table off center or by choosing an unusual point of view.

Before he begins a painting, Thornton likes to tone his canvas so that he is working against a middle value rather than white. To do this, he applies a thin coat of raw umber or raw sienna to the canvas, then wipes the excess off with a rag. Next, he draws his subject on the canvas with paint, using a neutral mixture such as raw umber and white. This drawing is so pale that it almost merges with the toned canvas. While the initial layer of color is still moist, Thornton rubs out the lights with a rag and mineral spirits. Next he blocks in the darks with thinned color. As he works, Thornton continues to refine the darks and lights in relation to the predominant middle value. He has found that by keeping his shadows relatively thin and transparent, while building up the light masses with opaque pigment, he can more easily create a three-dimensional effect.

Because flowers fade quickly, Thornton concentrates on them at first, usually finishing them over a period of two days. He then develops the other elements beyond the initial stage so that they work together with the flowers. Design changes, however, may be necessary in the final stages to help balance the floral subject with its surrounding elements. In one painting—*Narcissus and Blue Cup*—Thornton had finished the painting when he realized that the even background he had created wasn't enough to carry the painting. Using his imagination, he invented the patterned backdrop that now sits behind the vase and the flowers.

Paintings by John Thornton, 1983–84, oil on canvas:

1. **Mount Vernon Street Still Life**, 26" × 22" (66 × 55.9 cm), private collection.

2. **Daffodils**, 32" × 24" (81.3 × 61 cm), collection of Mr. and Mrs. Frederick C. Irving, Jr.

3. **Flowers and Jim's Shell**, 30" × 26" (76.2 × 66 cm), collection of Elizabeth Heard Guy

4. **Narcissus and Blue Cup**, 30" × 26" (76.2 × 66 cm), collection of Elizabeth Heard Guy.

5. **Wildflowers**, 16" × 16" (40.6 × 40.6 cm), collection of Mr. and Mrs. Geoffrey Kohn.

6. **Daisies and Dogwood Blossoms**, 28" × 32" (71.1 × 81.3 cm), collection of John Matrullo.

7. **Irises and Baby's Breath**, 30" × 25" (76.2 × 63.5 cm), private collection.

8. **Gladioli**, 16" × 12" (40.6 × 30.5 cm), collection of Letty Selkovitz.

9. **Flowers in Evie's Vase**, 32" × 25" (81.3 × 63.5 cm), collection of the artist.

1

2

3

4

5

6

7

8

9

Activating Space with Color and Shape

Karen Segal,
Gladiolus with Patterned Cloth,
1985, acrylic on canvas,
40″ × 30″ (101.6 × 76.2 cm),
photo by David Segal.

KAREN SEGAL's strong colors and shapes make her paintings come alive, activating the entire picture space. The actual setup is fairly simple, with two vases of flowers and a bowl of fruit arranged frontally against the strong diagonal of the patterned cloth. Certainly the pattern of the fabric and the different stripes in the background add excitement to the composition. But even more important are the colors and shapes Segal has selected for emphasis. It is the relationships between the colors and the shapes that lead the eye around the painting and generate visual energy.

COLOR CONNECTIONS

1. The play of warm and cool purples helps to define these flowers and convey their shapes.

2. Notice how the purple color is picked up in the flowers above and carries the eye over to the purple tulip.

3. The red fruit points the way to the red flowers through both color and positioning. In the flowers, however, the red is more subdued, to fit in with the surrounding purples.

4. The blue plum stands out in the foreground, but its color is picked up in the stripes and shadows behind, pulling it into the painting.

5. The orange sets up a vibration with the blue plum, but it also connects to the center of the narcissus.

6. The two lemons form an important connection across the painting, helping to balance the strong diagonal pull of the fabric.

7. The shifting patterns of the background are not arbitrary—they reinforce the way the eye moves: vertically, diagonally, and horizontally. Although the background is painted with cool blues, which tend to recede, its strong, flat design pushes forward so the eye doesn't wander into space.

Concentrating on Relationships

MINUTE CHANGES can totally alter a composition. Basing a series of paintings on the same or similar elements can teach you a great deal about how shapes and colors work together.

Look at these paintings by Karen Segal as a group and observe how many of the actual objects remain constant. In each painting, though, notice how these "repeated" elements seem different when they are even slightly rearranged. Note, too, how Segal simplifies the complex bouquets into their basic forms and colors. By simplifying what she sees, she arrives at the essence of her subject. Details never disrupt the overall effect.

In all of these paintings, Segal uses pieces of striped fabric and planes of flat color to direct the viewer's eye and weave the surface of the painting tightly together. She doesn't consider these "background" elements—every shape and color is equally important in creating the effect of the whole. When she paints, she works all over her canvas, balancing the different colors and shapes.

EXERCISE

Set up a still life like the ones shown here, using just three or four vases, masses of brilliantly colored flowers, a few pieces of fruit, and striped fabric. Choose a medium that will allow you to lay in

Top: Karen Segal,
Four Spring Bouquets,
1985, acrylic on canvas,
30″ × 40″ (76.2 × 101.6 cm),
photo by David Segal, courtesy of
Gross McCleaf Gallery, Philadelphia.

Above: Karen Segal,
Spring Flowers and Fruit,
1985, acrylic on canvas,
30″ × 40″ (76.2 × 101.6 cm),
photo by David Segal, courtesy of
Gross McCleaf Gallery, Philadelphia.

solid blocks of color quickly—gouache or pastels might be good choice. Plan to do three or four paintings within a definite time span; devote no more than an hour to each of the paintings. Setting a time limit can force you to work rapidly and to focus on the major colors and shapes—you won't have any time to move in on the details.

Begin your first painting. Don't execute a preliminary drawing. Instead, work directly on your support with whatever medium you have chosen. Lay in large blocks of solid color, without shading, simplifying the forms that you see. Try to suggest space through color relationships; let bright colors move forward and cooler, muted ones recede. As you lay in each block of color, pay attention to how it affects all the other portions of your painting.

For the next two or three paintings, use the same elements, but rearrange them slightly. Move flowers from one vase to another and reposition the fruit. If you like, add or subtract one element. As you change your setup, different relationships should stand out. With each arrangement, pay attention to the color repetitions and color contrasts, and decide which ones are most important in moving your eye around the composition. Then use these relationships to enliven your painting.

Top: Karen Segal,
Flowers and Fruit with Stripes,
1985, acrylic on canvas,
26" × 32" (66 × 81.3 cm),
photo by David Segal.

Above: Karen Segal,
Flowers with Plant and Window,
1985, acrylic on canvas,
30" × 40" (76.2 × 101.6 cm),
photo by David Segal.

Working Expressionistically

WHAT stands out in Jim Touchton's paintings is the energy of the brushwork and the excitement of the color. Touchton works directly, drawing with his paint. Using fairly wet pigment, he builds his color from thin to thick.

Strongly influenced by the Abstract Expressionists, Touchton moves all over the canvas or paper, never pausing in one area. He doesn't concentrate on any one object; instead, he gradually pulls everything into focus, sharpening the colors and forms. This way of working is very intuitive—but it is not haphazard. You have to understand how your eye and hand work together and how best to capture the overall impact of what you see.

In both the paintings shown here, note how the flowers fill the view. Although both still lifes are set in front of an outdoor scene, it is really the flowers that become the landscape. If you look closely, you can see how Touchton has used color repetitions and echoes to integrate the outside view with the flowers and to keep our eyes from wandering into distant space. In *Bright Bouquet*, for instance, the white flower near the center seems to merge with the building behind, bringing everything forward. Also note the repetitions of the greens in the foliage of the flowers, the vines on the building, and the flower pot on the right. In *Stargazer*, there are connections between the red building and red flowers. But perhaps even more important is how Touchton's gestural brushwork directs our eyes around the painting and at the same time gives the flowers a tactile quality—so that we can almost feel them.

Jim Touchton,
Bright Bouquet,
1983, oil on canvas,
48″ × 72″ (121.9 × 182.9 cm),
private collection.

Jim Touchton,
Stargazer,
acrylic on paper,
30″ × 22½″ (76.2 × 57.2 cm),
private collection.

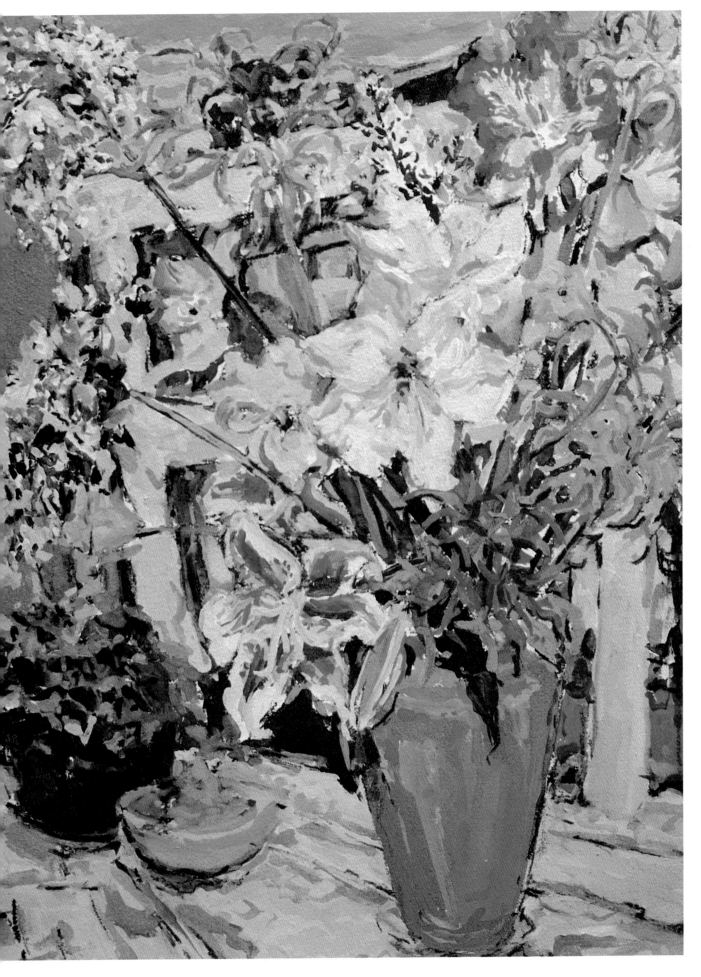

Reexploring the Same Subject

*E*VERY still life you set up holds many painting possibilities, and it can be both instructive and fun to rework the same subject matter. The challenge is to see your subject anew—to rediscover it—while building on all that you have learned from painting it before.

From time to time Harriet Shorr explores a subject in a relatively small-scale chalk or pastel work and then later does a large-scale oil painting, as in the two pieces shown here. She doesn't really consider the chalk drawing a "study"; it is a finished piece in its own right, not a preliminary to the oil painting. Indeed, it was only some time after she'd completed the chalk drawing here that she

thought she'd like to try the same subject in oil. She then set up her still life all over again—with new flowers.

By changing both the scale and the medium for her oil painting, Shorr forced a reconsideration of both composition and color. Notice that in the oil painting she chose a viewpoint slightly further back, so that every object is fully seen within the borders of the canvas. This change is important given the much larger size of the oil painting. In the chalk piece the cut-off view has an intimate feeling. But try to image this view blown to 5 × 7½ feet—the objects might take on a comic and at the same time threatening aspect. Instead, seen in their entirety within the oil painting, they retain their dignity.

Also notice the much more intense color in the oil painting. This, too, is appropriate to the change in scale, but it is also appropriate to the change in medium. Oil covers the surface differently from chalk. Although you can build intense color with chalk, it has a different visual impact: there's always a sense of its powdery base and its fragility. In contrast, when oil is applied opaquely, the color feels much more solid; it has a sense of permanence that is almost impossible to achieve with chalk. This doesn't mean that one medium is better than the other; they are simply different. But because they *are* different, they encourage different approaches.

Left:
Harriet Shorr,
Kumquats,
1981, chalk on paper,
30¼″ × 39″ (76.9 × 99 cm),
private collection.

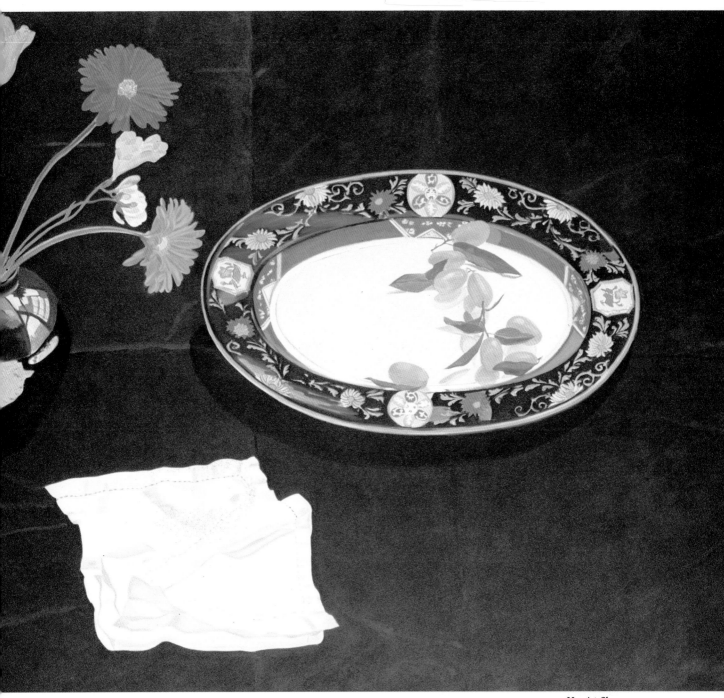

Harriet Shorr,
Kumquats,
1982, oil on canvas,
60″ × 90″ (152.4 × 228.6 cm),
private collection.

Generating Dynamic Excitement

Facing page: Charles Le Clair, **Amaryllis and Navajo Rug,** *1985, oil on canvas, 48″×36″ (122×91.4 cm), courtesy of More Gallery, Philadelphia.*

*E*VERYTHING ABOUT Charles Le Clair's painting is charged with energy. Because of the vantage point he has chosen, the eye enters the composition from high above, then sweeps down to the pot and ground, only to move up again following the surge of the flower and leaves. The strong geometric shapes that make up the rug and the way these shapes are painted reinforce the dynamic lines that run through the painting. To see how forceful this composition is, try turning the painting on its side so that what is now the right side becomes the bottom. You'll immediately notice how the strong diagonal composition is balanced by counterthrusts.

As you look at this painting more closely, you'll notice that in a sort of visual *tour de force*, the slab of dull plastic set beneath the rug and the flower pot reflects objects that aren't really present. The reflection of the peach is believable enough, but the swordlike leaves reflected in the plastic don't correspond at all with the actual plant. They do, however, accentuate the explosive energy that runs through the painting.

DETAIL (top)
Le Clair lays his color on the canvas with such strong, expressive strokes that you can almost feel the paint being put down. Note how the edges of the brushstrokes are quite obvious and how the direction of the strokes helps emphasize the lines of the composition. This loose, gestural brushwork helps build the painting's drama.

DETAIL (bottom)
Although earthtones dominate, there's a lot of rich color when you look more closely. Here the bluish grapes are tinged with touches of warm orange; it is the push and pull of warm and cool that gives three-dimensional form to the fruit, more than traditional modeling with lights and darks.

Capturing a Moment in Time

SIMPLE, everyday objects can be just as interesting as complicated, ornate subjects. A few daisies in a jar on your windowsill or a bunch of tulips casually grouped on a table in your hallway can inspire you to paint beautiful still lifes. You simply have to see the possibilities all around you.

Kathleen Pawley's paintings seem to capture perfectly the appeal of flowers. Flowers last for just a short time, yet while they live they can delight and surprise anyone who encounters them. Flowers help transform the simplest moments in life to moments filled with beauty.

In Pawley's *Ripening*, tomatoes and petunias are washed by warm golden light. Though scenes like this one are commonplace, it takes talent to isolate this kind of slice of life and give it meaning in a painting. Here it is the light that transforms the scene. The tomatoes and flowers are carefully rendered, with their forms clearly defined by the sunlight; the rest of the painting is soft and slightly out of focus. Pawley's method might be termed *selective realism*: the objects that lie at the heart of her composition are precisely rendered; other areas—outside the main interest—are depicted in a loose, painterly manner.

In *Glass Bowl with Iris*, the expected subject—flowers in a vase—is outside our view.

Kathleen Pawley, **Ripening,** *1984, watercolor on paper, 20″ × 26″ (50.8 × 66 cm), collection of the artist.*

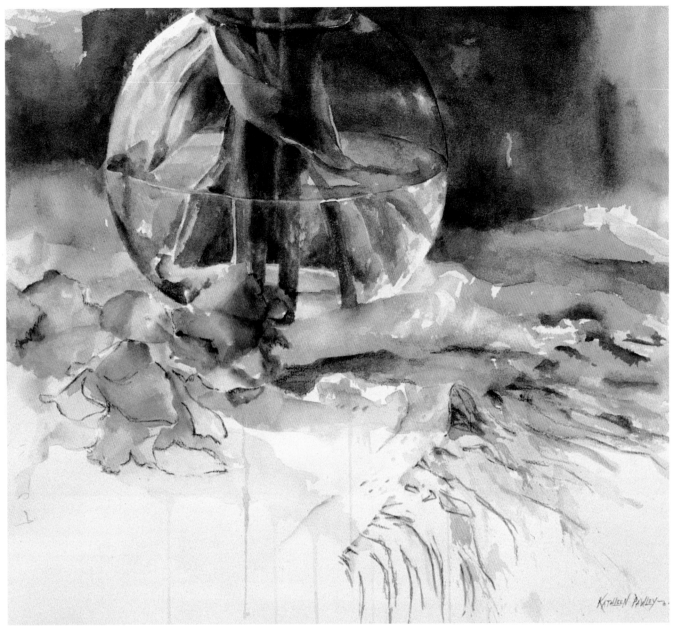

Kathleen Pawley, **Glass Bowl with Iris,** 1985, watercolor on paper, 18" × 20" (45.7 × 50.8 cm), collection of the artist.

What matters to the painting are the delicate irises that lie beside the vase, the stems inside the vase, the fabric's soft fringe, and the round glass vase itself. By cropping in on her subject in this way, Pawley suggests a fleeting glimpse, "caught" in passing. Her use of the transparency of watercolor, as well as focused and unfocused areas, enhances the transitory feeling.

DETAIL
The irises are painted loosely, with a minimum of detail. In places the charcoal lines sharpen the form; but overall the color flows gently, in keeping with the painting's delicate mood.

EXERCISE
Try to discover floral still lifes in your everyday environment. As you move about your house, your yard, or your office, be sensitive to what you see. When something strikes you as particularly appealing, draw it, then paint it on the spot. If you can't stop in the middle of the day and start to paint, sketch what you see, jot down notes that will jog your memory, or, if possible, take photographs.

Evoking Mood

*O*NE OF THE easiest ways for you to compose a painting is to group together objects that mean something special to you and that are thematically connected. Here each element—the glass of wine, the teacup and saucer, the watch, the fruit, the vase, and the roses—helps set the quiet, bittersweet mood that pervades Kathleen Pawley's painting. Even if the actual story that lies behind the painting remains undiscovered, it's easy to create a tale that fits the situation.

Although the painting is carefully composed, Pawley manages to summon up a brief moment in time that at first seems casual. The cup, saucer, and glass of wine suggest a human presence; the clock and the watch suggest that time stands still. Because the painting is seen from above and at an angle, there is a sense that the viewer has stumbled on a scene filled with potential human drama.

DETAILS
Every element in this painting is carefully rendered, adding to the timeless drama of the scene. Each object seems to stand on its own, inviting us to take a closer look and drawing us further into the world of the painting. When you focus on the front rose, for example, you begin to notice the delicate variations in the pinks and how the bottom petals seem to be turning in color—the flower will be gone in just a day or two. Try to imagine this painting without all this detail. You'll realize that the detail contributes to a sense of tension in the painting— it's almost as if we can't look closely enough.

Kathleen Pawley,
Of Wine and Roses,
1983, watercolor on paper,
30" × 22" (76.2 × 55.9 cm),
collection of the artist.

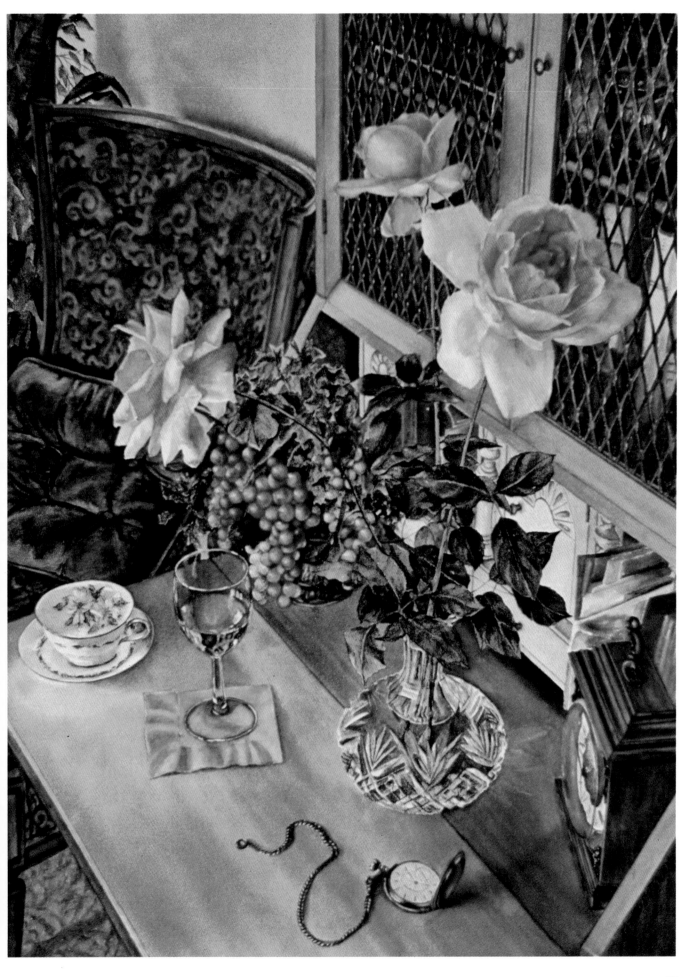

Experimenting with Visual Ambiguities

*S*EEN FROM an unusual point of view, this painting by Charles Le Clair is filled with fascinating visual ambiguities. At the top, you can see the tile floor on which the setup is placed. A piece of dark plastic under the plant and a clear mirror on the left reflect the fruit and flowers, and portions of the room as well.

The ambiguities that Le Clair sets up create an exciting sense of shifting back and forth in space. When you concentrate on the begonia (1), its reflection in the dark plastic (2) seems far away, in a deep space beneath it. When, however, you shift your gaze to the left and see the reflection in the mirror (3), you are quickly brought back to the surface by the lighter image. The triangle formed by the grapes and pear (4) helps to balance the light mirror reflection (3), as well as the flower and shadow at the top.

In a way, the most puzzling area of the painting is the reflection from the room outside our view, found in the upper left corner of the painting (5); it's ambiguous enough to make one question everything else in the painting. Finally, there's a slight shift in the diagonal of the tiles and that of the plastic (6)—which heightens the tension that runs through what at first seems a quiet, lyrical painting. No matter how long you study the com-position, its logic and order keep shifting.

Watercolor is in many ways an ideal medium for setting up complex visual relationships like those you see here. Because it is transparent, you can set up shifting layers of color and substance easily. Here the delicate, soft tones that Le Clair uses help to pull the painting together and offset any sense of rigid geometry.

EXERCISE

Incorporating mirrors or other reflective surfaces can prove a fresh and exciting way of animating your floral still lifes. Set underneath a vase, a mirror reflects all or part of your composition. Placed one way, it may just catch the undersides of the flower stalks and a few leaves; placed another way, it can reflect more of the composition than you actually

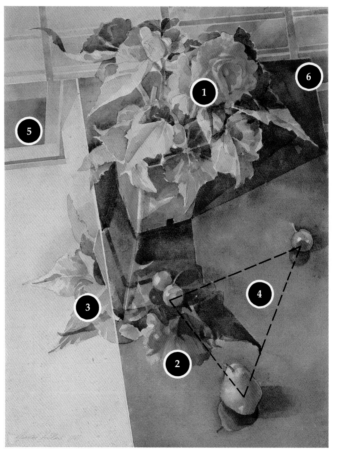

frame on the paper. Using mirrors as a compositional tool is a kind of magical sleight of hand.

Begin with a simple, classical composition—one vase, centered on the support, filled with simple flowers. Beneath the vase, center a mirror. As you paint your picture, be conscious of sunstruck portions of the mirror as well as the objects that it actually reflects.

Next place a mirror behind your subject; it will reflect your studio wall as well as the back of the objects you have assembled. Or try incorporating small mirrors into your still lifes. For example, in a setup consisting of a vase, some flowers, a necklace, and a fan, place a small silver compact opened to reveal the mirror inside; the mirror will expand the visual limits of the setup you are painting.

Some artists use sheets of glass to set up interesting optical sensations. Place a piece of clear glass over a bunched up piece of fabric, then construct a still life on top of the glass. The fabric will, of course, be visible through the glass, but on its surface the glass will also reflect the objects you are rendering. This may sound difficult to paint. Remember that you are never actually *painting* a mirror or a piece of glass. Instead, you are painting the reflections that you see or what you see through the glass.

Charles Le Clair, **Orange Begonia,** *1981, watercolor on paper, 30″ × 22″ (76.2 × 55.9 cm), collection of Mr. and Mrs. Gerald E. Parent.*

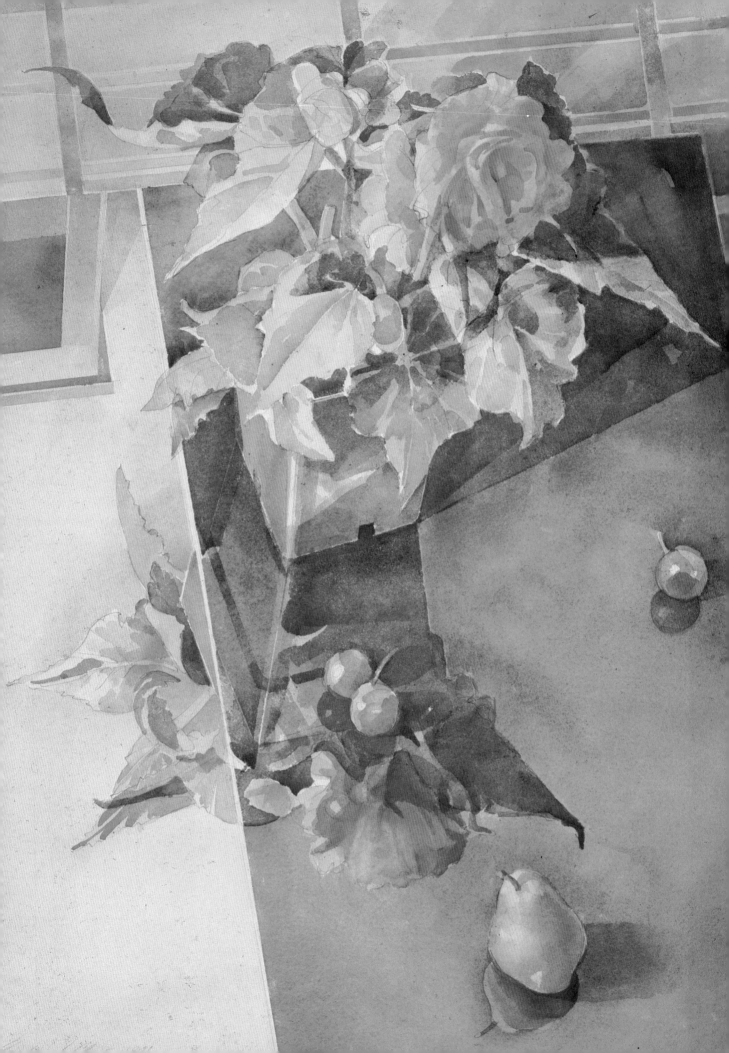

Exploring Symmetry and Mirror Reversals

*I*N BOTH these paintings, Nancy Hagin experiments with symmetry and reflected images. In *Country Lace*, symmetry is suggested by the mirroring of the vase and flowers in the tray; in *Two Azaleas*, it is conveyed by the paired pots of flowers and their reflections. In neither painting, however, is the symmetry exact—slight variations keep the composition from being static or dull. And there are also fascinating visual complexities to explore.

The painting *Two Azaleas* began quite simply: Hagin bought the plants and liked them so much she decided to paint them. She placed them on her windowsill, but she didn't want to paint the windowsill itself so she covered it with a mirror. To her delight, the mirror reflected the color of the sky as well as a few of the buildings outside.

In the painting, the mirror also creates visual tension and helps to counter any feeling of rigid symmetry. The lone flower caught in the reflection in the center calls attention to small differences between the plants. Notice, too, how the eye shifts from looking *down* into the reflected pots to gazing almost *up* at the three-dimensional flowers. Although the overall perspective is clear, as you focus on one area or another, the way you see the painting changes.

In contrast to the relative simplicity of the setup in *Two Azaleas*, the scene in *Country Lace* overflows with detail. Obviously paintings as rich in detail as this one take a long time to complete. Hagin first executes a very careful pencil drawing, since once she starts working with watercolor it is impossible to make major changes. As she paints, she works all over, covering the white paper with color and moving from one area to another as the first area dries. At times she may get lost in the pattern, but finding her way out is part of the fascination of painting.

In the finished painting, the mirror image creates a sense of orderly repetition and balance. Yet both the dramatic birds of paradise and rich detail invite a closer look. Note, for instance, how the reflected curtains become light set against a dark ground, while the actual curtains become dark against the light outside. Also observe how the cross shape in the center, formed by the window frame and its reflection, draws attention to the flat picture plane. At the same time there's a strong sweep back into space created by the perspective of the tray. There are many different ways of looking at this painting—its suggested symmetry is only the starting point.

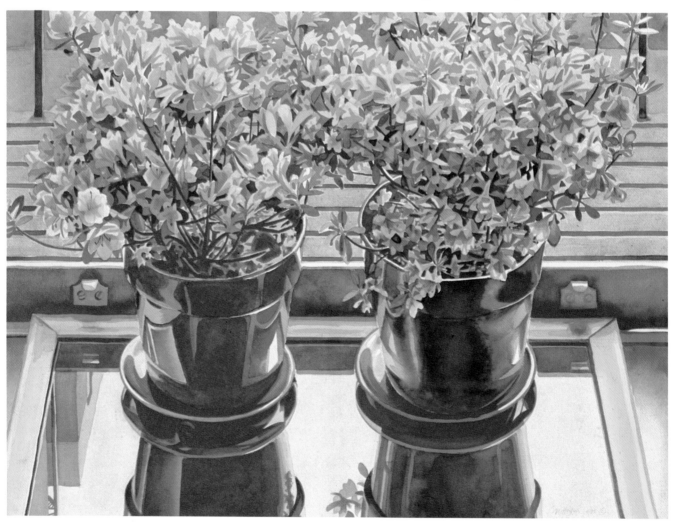

*Nancy Hagin, **Two Azaleas**, 1985, watercolor on paper, 22″ × 30″ (55.9 × 76.2 cm), collection of Mr. and Mrs. Thomas Barrow.*

*Right: Nancy Hagin, **Country Lace**, 1983, watercolor on paper, 41½″ × 29½″ (105.4 × 75 cm), collection of Mr. and Mrs. Albert Marberger.*

Handling Complex Textures and Details

P. S. Gordon, **Tug of War,**
1980, watercolor and gouache on paper,
28" × 20" (71.1 × 50.8 cm), collection
of Mr. and Mrs. Jack Alexander.

Facing page: P. S. Gordon,
Flor, Flora, Where's the Fauna?
(Starling under Glass),
1984, watercolor on paper,
52½" × 40¼" (133.3 × 101.7 cm),
collection of Mrs. Glenn C. Janss.

*F*LOWERS, fabric, streamers—even birds—make up the complex patterns that you see here. Balancing so many visual elements simultaneously is impossible for most people—and it requires a lot of patience.

Although these paintings may at first seem almost intimidating in their complexity, P. S. Gordon draws the viewer into them through the suggestion of a narrative, hinted at in the titles, and through the powerful symbolism of the objects he paints. Even when the objects are relatively small, as in *Flor, Flora . . .*, they stand out against the incredibly rich backgrounds because of the care with which Gordon renders them and because of their mysteriousness. Gordon explains that these objects have a strong, personal meaning to him, although this personal meaning may not be apparent to the viewer. But the objects are definitely provocative, and they intrigue the viewer.

These paintings take a very long time to complete. For a large painting like *Flor, Flora,* Gordon may spend two months just drawing his subject before he starts to paint; two more months may pass before a painting is finished. In his drawing, Gordon carefully plans every element of his composition, so when he starts to paint, he knows exactly what he is trying to do—which can be critical with watercolor. After laying in the dark areas, Gordon paints one object at a time. Although he may for short periods become lost in the complex details, his vision in his mind's eye of how the finished object will look helps him find his way.

The kind of dedication and close attention to detail required to execute paintings like those you see here may not suit everybody's temperament. On a smaller scale, though, concentrating carefully on texture and detail can be a fascinating painting experience.

Integrating Elaborate Floral Patterns

*W*ORKING WITH any elaborate pattern is challenging, but the challenge becomes much greater when you set flowers against strong floral patterns. Together the two elements can be so visually overwhelming that the viewer can concentrate on little else. Although complexity is potentially intriguing, there needs to be a solid structure uniting the details and organizing the painting into a whole.

In the two paintings shown here, Harriet Shorr and Nancy Hagin have created simple, balanced compositions. This and their use of limited color provide a counter to all the detail. The viewer is encouraged to step back to grasp each painting in its entirety as well as to move in to explore details.

The scale that Shorr uses—her painting is 5 x 7½ *feet*—is also important. An intimate subject becomes monumental, and the viewer is enveloped in the field of the picture. The bold chevron formed by the shawl and the strong black and white contrast set up a dynamic abstract pattern, dividing the picture space. At the top of the chevron, however, the vase shoots upward, and the flowers spill up and out, directing attention to the white-on-black pattern that decorates the shawl and leading our eyes around the painting.

Looked at alone, the delphiniums and vase are clearly three-dimensional. The perspective of the shawl also creates a sense of space.

Nancy Hagin,
Four Enamel Pitchers,
1984, acrylic on canvas,
48" × 42" (121.9 × 106.7 cm),
private collection.

The shawl's pattern, though, is strongly two-dimensional. These opposing two- and three-dimensional forces exert a powerful visual tension: seen one way, the delphiniums merge with the white floral patterns on the shawl; seen another way, they stand out against the fabric. All this generates excitement in looking at the painting and gives the decorative patterning life.

In *Four Enamel Pitchers*, Nancy Hagin also creates tension between two- and three-dimensional space. There is a very clear recession in space, from the pitchers below in front to the pitchers above in back. At the same time the whole canvas is filled with patterns—from the blue-and-white floral design on the fabric in the center to the deep, shadowy folds of the white material on the sides to the mottled surface of the spatterware pitchers and flowers themselves.

All this detail might be overwhelming, but there are also larger areas of blue and especially white that serve as welcome resting places for the eye. Equally important are the steadying vertical and horizontal lines, which order the composition. There's also a balanced "X" when you look at the pitchers from the lower left to the top right and vice versa. Moreover, the clean geometric shapes of the pitchers and bowl give Hagin's painting a classical feeling. Despite all the patterns, in many ways, this work is as soothing and harmonious as a Shaker interior.

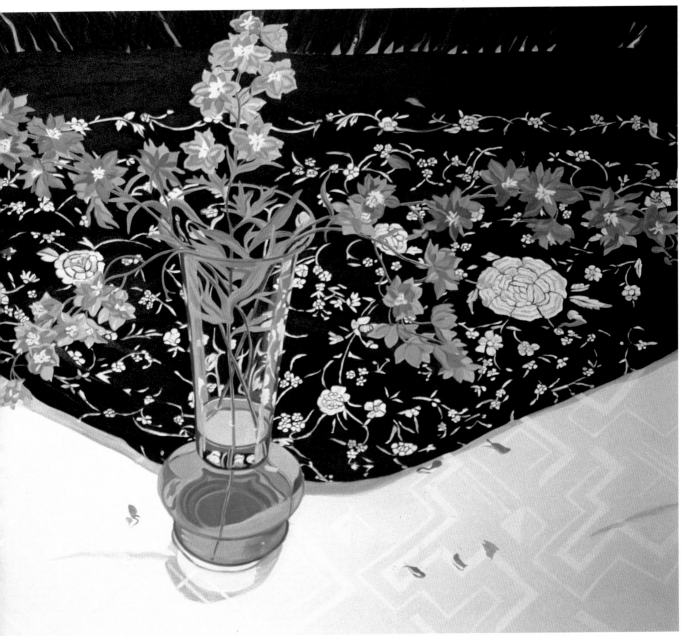

Harriet Shorr,
Delphiniums,
1983, oil on canvas,
60″ × 90″ (152.4 × 228.6 cm),
private collection.

Searching for Abstract Patterns

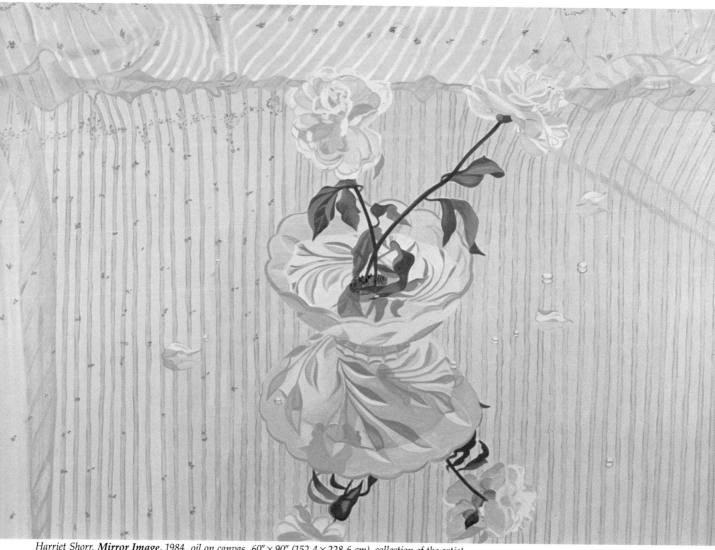

Harriet Shorr, **Mirror Image,** *1984, oil on canvas, 60" × 90" (152.4 × 228.6 cm), collection of the artist.*

*E*VEN THE most simple, straightforward, and realistic setup—a vase and a few flowers—can be dynamic and challenging. Using ordinary, realistic subjects as a starting point, Charles Le Clair and Harriet Shorr transform what they see into paintings that seem almost abstract in their treatment of pictorial space.

In *Mirror Image*, Shorr paints an intimate, fragile subject—a cut-glass bowl and two peonies—on a grand scale; the bowl and flowers are more than two feet tall. Mere size makes us look at the subject in a new way. As interesting as scale, though, is the way Shorr displays her subject, setting it on a mirror that reflects the flowers and bowl as well as the curtain of a window that we can't see. At the very top, however, we do see a bit of the actual curtain resting on the mirror.

Seen on a large scale, the strong lines of the fabric give the composition an abstract feeling—the pattern pushes everything toward the surface of the picture. The pattern never becomes relentlessly geometric, though, because in places the lines wobble and because the fabric is speckled with irregular flecks of color. There's a continual interplay, throughout the painting, between formality and informality, symmetry and asymmetry.

Although Le Clair's painting is very different, it also has a strong, underlying abstract pattern that organizes what we see. A vertical glass vase sits squarely in the center; the surrounding fruit seems carefully placed to direct the eye both toward the vase and, in a rough square, around it. Above, the graceful lines of the anthurium provide a contrast, but they, too, lead the eye around, in a rough circle.

Now look at the bold, geometric design of the fabric. Then squint your eyes and reexamine the painting as a whole. Try to forget about the actual objects and see the painting as an organization of shapes and colors. There is a striking similarity between the overall design and the pattern of the fabric.

Yet Le Clair's painting is far from geometric in feeling. The delicate transparency of the watercolor medium, the slightly jarring interaction between the complementary reds and greens, and the irregularity of the flowers all keep the painting from becoming static and make it visually exciting.

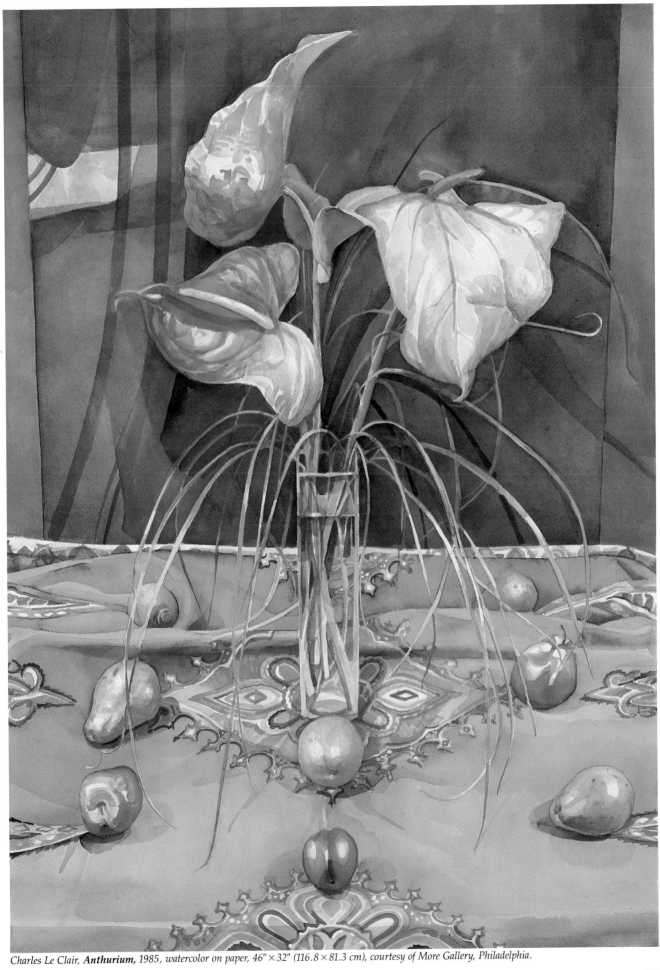

Charles Le Clair, **Anthurium,** *1985, watercolor on paper, 46″ × 32″ (116.8 × 81.3 cm), courtesy of More Gallery, Philadelphia.*

Creating Exciting Contrasts

*F*OR ELIZABETH Osborne, the still life setup is primary. The objects she uses both inspire her and give structure to her paintings. Only when she is totally happy with the arrangement of the objects she has gathered together does she add flowers; she chooses the flowers to provide an exciting contrast in color and form to the other elements.

In both these paintings, the flowers sound a delicate note within the strong color and geometry of the composition. In *Pink Dogwood*, the delicate tracery of the flowers contrasts sharply with the solid geometric vases and backdrop. The vases are grouped closely together—even their shapes rhyme, locking them one to the next—while the dogwood blossoms meander above. The strong horizontal band, with its vertical stripes, sets up visual tension, pushing the objects forward and almost splitting the top and bottom.

It is the dogwood that helps to hold the composition together; it also keeps the geometry from becoming static and severe. Focus on where its branches start in the white pitcher, then shift to its silhouette on top—there's a kind of visual tug back and forth as you try to bring the two views in line. Now try covering the top of the painting with a sheet of blank paper. It should be clear just how much interest and excitement the dogwood blossoms provide.

In *Forsythia*, Osborne sets large flat areas of color against one another, dramatically dividing the picture space, as you can see in the diagram shown here. The light areas that surround the arching slabs of red, however, keep them from becoming too overwhelming. Countering the bright colors, too, is the black vase in between. Because it is the darkest element in the painting, it forces the eye away from the reds toward the center of the scene. The strong shape of the amaryllis on the left accentuates the delicacy of the forsythia on the right; the forsythia, in turn, sets off the large areas of color. Together, the flowers add an intimate touch to this powerful composition.

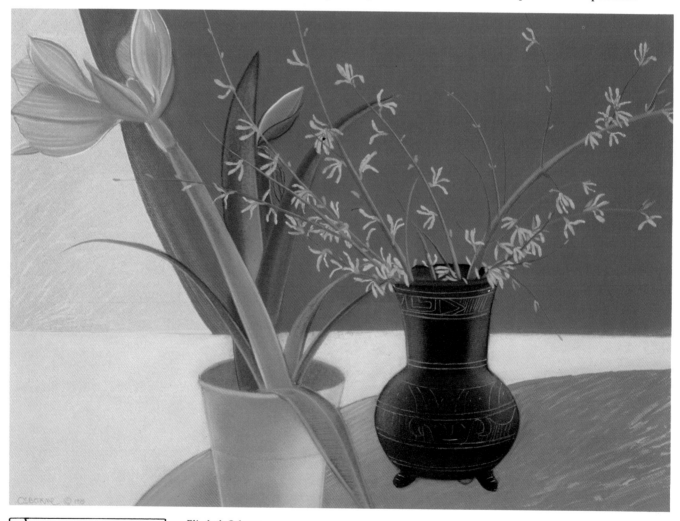

Elizabeth Osborne,
Forsythia,
1985, pastel on paper,
30" × 37" (76.2 × 94 cm),
collection of the artist.

Elizabeth Osborne,
Pink Dogwood,
1982, pastel on paper,
37½" × 29½" (95.3 × 75 cm),
private collection.

Pairing Unusual Objects with Flowers

*U*NEXPECTED elements —birds or an old doll—can make floral setups fresh and exciting. The unusual objects you gather together may have a particular meaning for you, or you may choose them because you like their shapes and colors.

In his gouache painting, Gilbert Lewis groups objects that were very special to his father—parakeets and horse-chestnut blossoms. In a way this painting is a memorial to his father, though this meaning would never be immediately obvious to the viewer. By combining playful and unusual objects with formal flowers, Lewis does hint, however, that he has a personal story to tell.

To pull the different objects in the painting together, Lewis uses a strong circular rhythm. The horse-chestnut leaves, the bird that flutters in midair on the right, and the curve suggested by the arrangement of the parakeets below keep the eye moving about the picture—in a way that is similar to the implicit movement of the toy ferris wheel in the lower left.

Nancy Hagin's approach is different from Lewis's. In setting up her still life, she wanted to fill the image and work with a lot of color. She

Nancy Hagin,
Calico,
1984, watercolor on paper, 29½" × 41½" (75 × 105.4 cm), collection of Stuart Handler.

Left:
Gilbert Lewis,
Still Life with Parakeets,
1980, gouache on paper, 30½" × 22" (77.5 × 55.9 cm), collection of the artist.

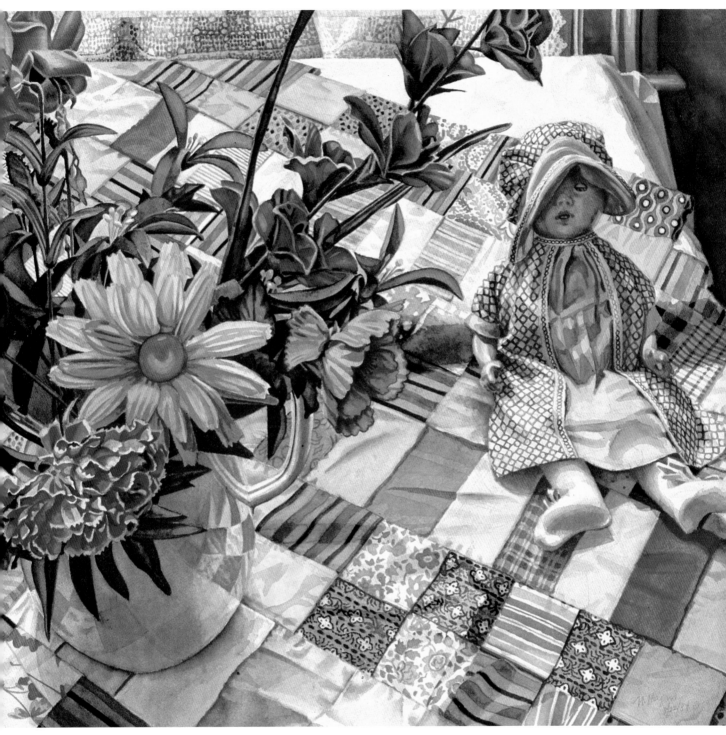

was attracted to the interaction of three-dimensional flowers with the lively colored patterns of the quilt. The doll, which she had recently bought at a flea market, just seemed to fit in. Its patterned yellow gown relates to the strong patterns of the quilt, and it provides a counternote to the flowers.

Actually, the flowers that Hagin uses here are made of silk. Because of the length of time it takes her to complete a painting, she prefers artificial flowers—she never has to worry about them dying or flopping over when she is in the middle of a work. At the same time, although they are artificial, they do suggest a natural form.

The different personalities of the objects in *Calico* might seem to set them apart, yet Hagin skillfully binds the painting together. The rich colors and the vivid patterns found in the quilt, the flowers, and the doll all draw the viewer into the painting. The vantage point that Hagin uses is equally inviting. In a sense, however, it is the quilt that suggests an underlying unity. The eye moves back and forth, patching together the many details, much as one would piece a quilt.

Discovering New Ways of Looking

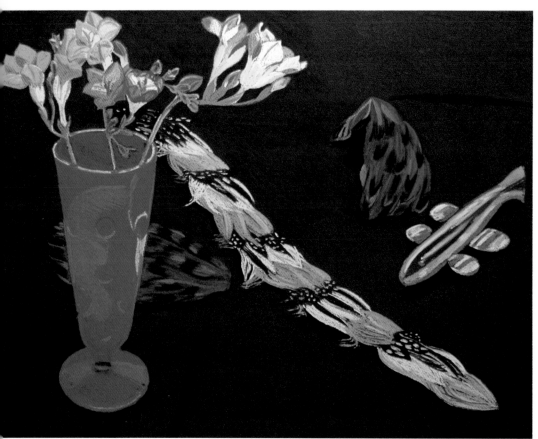

Harriet Shorr,
Freesias/Feathers/Fish,
1985, pastel on paper,
22" × 30" (55.9 × 76.2 cm),
private collection.

*H*OW DO YOU choose a subject to paint? Every artist has his or her preferences, but sometimes it can be a good idea to break old habits and to change the way you select objects for a still life. You might, for example, ask several different friends to each choose an object. Or you might try the method Harriet Shorr used for the two works shown here.

In *Blue Flags/Beret/Bow Tie* the main objects all begin with the letter *B*; similarly, in *Freesias/Feathers/Fish* they start with *F.* Shorr actually did a series of twenty-six pastels, each based on a different letter of the alphabet. The idea behind this was to get away from her usual associations; at times she even used a dictionary to find an appropriate object. By choosing things in this arbitrary way—where there wasn't any obvious connection, except for the initial letter—she forced herself to look at her subject differently. It became a challenge to find a *visual* connection that would make everything work together.

This kind of challenge can have unexpected results. Shorr, for example, found that the change in subject matter led her into using extremely intense color and this in turn suggested new directions for other paintings. By setting up similar challenges for yourself, you, too, may be "surprised" into seeing differently and discover a new excitement in your subject.

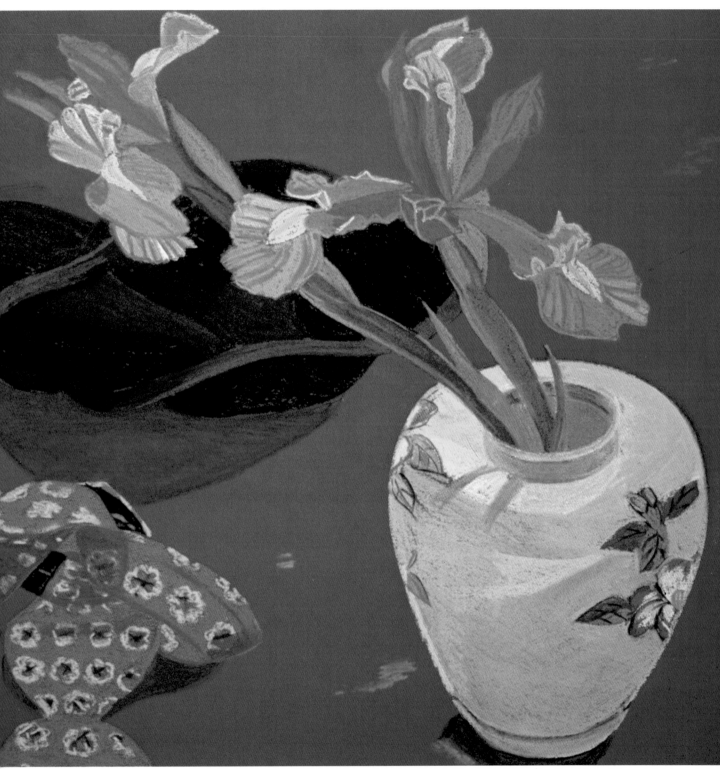

Harriet Shorr,
Blue Flags/Beret/Bow Tie,
1985, pastel on paper,
22″ × 30″ (55.9 × 76.2 cm),
courtesy of Fischbach Gallery,
New York City.

Articulating Shallow Space

AT FIRST GLANCE, these paintings seem totally different. Charles Le Clair's canvas is elaborately packed with flowers, signs, baskets, pedestals, curtains, hearts, and ribbons. Elizabeth Osborne's watercolor is composed of simple, understated forms—a few flowers, vases, and shelves, plus a piece of patterned cloth. In Le Clair's painting, relatively light forms stand against a dark, mysterious backdrop. In Osborne's, the relatively dark forms are silhouetted by a clear, white backdrop.

Despite these differences, prolonged study of the two works reveals that they share a similar structure. In both, the artists work with a shallow pictorial space. They push everything very close to the picture plane and experiment with shifting layers. Color, too, activates the shallow space, keeping the eye moving about, looking first at one object, then at the next.

Osborne arranges her still life subject with classical elegance and restraint. The objects have a geometric clarity; the frontal way in which they are presented and their strong, bold colors accentuate their clean, crisp lines. The structure seems simple, almost self-evident—but try sketching the composition to grasp how sophisticated this work really is. The two shelves are equidistant from the top and the bottom of the paper. The centrally placed yellow vase rises up to meet the lower shelf. The squat shape of the light blue bowl on the top left balances the tall black vase on the lower right shelf. The blue vase creates a similar diagonal tension with the orange vase through the vibration of the complementary colors.

Notice, too, the contrast provided by the flowers, with their flowing lines, and how the flower stalks move upward and outward toward the objects on the top shelf. The erratic pattern of the fabric adds a whimsical note to the painting; the fabric itself moves behind and in front of the shelves, creating a sense of shifting space.

Because it is so densely packed with shapes and colors, the structure of Le Clair's painting seems, at first, more difficult to grasp. Examine it carefully, though, and you will find that it, too, has an underlying order. The architectural elements that frame the scene make it clear that you are looking at a window. This sets up a kind of visual *tour de force*—since a painting is, in a sense, a window on the world, it is as if Le Clair were painting a picture of a painting.

Behind the pillar lies the glass of the window. Behind it hang the circles and the hearts, and behind them stand the bouquets on their pedestals. The lavender curtains seem just inches behind the pedestals. At some indeterminate distance, though certainly not very far back, is the lattice screen, and near the top you see reflections from outside.

All these levels create a sense of thin planes, moving back in space—the reflections then bring the eye forward to the picture plane. But there is also another way of seeing the order in this painting. Squint your eyes and try to see the painting abstractly as a combination of colors and shapes. Look at the interplay between horizontals and verticals, circles and rectangles, lights and darks, warm and cool colors. What makes Le Clair's painting so fascinating is the way the eye shifts back and forth from one level or relationship to another so there is a feeling of lively movement within the shallow picture space.

Elizabeth Osborne, **Summer Lilies,** 1984, watercolor on paper, 37½" × 30" (75.5 × 76.2 cm), private collection.

Charles Le Clair, **Hearts and Flowers,** *1985, oil on canvas, 58" × 38" (147.3 × 96.5 cm), courtesy of More Gallery, Philadelphia.*

Combining Still Life with Landscape

Above:
Elizabeth Osborne,
Delaware River,
1984, oil on canvas,
43¾" × 62" (111.1 × 157.5 cm),
courtesy of Marian Locks
Gallery, Philadelphia.

Opposite page:
Elizabeth Osborne,
Delaware River, Summer,
oil on canvas,
45½" × 31½" (115.6 × 195.6 cm),
collection of the artist.

*I*N THESE two views from a window by Elizabeth Osborne, the landscape is as much a part of the composition as the still life. Together, the simple geometric clarity of the clouds, buildings, bridge, river, fruit, containers, and flowers creates a calm, soothing mood. Many artists have used the view through a window to suggest the outside world beyond the interior of the still life. Osborne, however, does this in an unusual way, opening up the space dramatically. Only the windowsill hints at the presence of a window—there is no frame—so the landscape seems to dominate the composition.

Using a window view with a still life involves combining both different elements and different kinds of space. In a still life the space tends to be shallow and intimate, while landscapes can suggest vast vistas. Scale can be problematic, too; the objects in the still life may seem gigantic against a distant landscape.

In Osborne's paintings there are exciting contrasts between the foreground still life and background landscape, yet there are also connections that unify the work. First, the colors in the foreground are related to those in the landscape. The pale sand- and salmon-colored buildings on the distant shore key in with the color of the windowsill; the blue water acts as a bridge to the blue sky. The longer you examine these paintings, the more color echoes you find.

Osborne also uses repetitions of form to link the different scenes. In *Delaware River*, the shapes of the containers are echoed in the buildings in the distance. In *Delaware River, Summer*, the vases seem almost like towers. Although the bright colors of the flowers make them stand out against the grayish landscape, there's a similarity in the way the flowers and the buildings cluster together.

The way Osborne structures the picture plane is also

important. In the vertical view all the space on the top balances the activity below. Although, in the horizontal view, the diagonal of the cloth leads the eye into the distant space, both the bright colors of the foreground objects and the strong horizontal bands of the windowsill, river, shoreline, and sky

bring the eye forward.

To understand more clearly how Osborne connects the near and the far, and how the two are interdependent, look at the split version of *Delaware River* shown here. When you focus on just the objects in the foreground—without the rhyming shapes in the back-

ground—the objects seem much more separate and unrelated. Next turn to the background. Without the colors and the shapes of the still life, the buildings and clouds seem dull. Now look again at the actual painting and observe how much each half affects the other portion of the painting.

Part Five

MOVING OUTDOORS INTO GARDENS

GARDENS may be made up of individual flowers, but when you start to paint flowers outdoors, you'll soon discover that seen *en masse* individual blossoms often seem to disappear. They merge together, forming masses of color and strong, definite shapes. You'll find, too, that dealing with these large, powerful areas of color and the patterns they create is quite different from painting flowers indoors. When you set up a still life in your studio, you can control every element in your composition; when you paint outdoors, however, you must deal with changing weather, changing light, and changing seasons. And you can't physically rearrange the setup—instead, you must discover the structure in what you see.

If you have a garden, no matter how small, try to look at it in a new way. Don't view it pragmatically ("It's time to weed again"). Instead, view it with composition in mind, balancing colors and values. In short, look at it from the point of view of an artist.

If you live in a place where gardening is difficult or even impossible, go to a local rose garden, a botanical park, or to the home of a friend who plants flowers. The point is to get outside and to study the way that flowers grow.

Kathleen Pawley, **Botany Monotony**, 1984, watercolor on paper, 22" × 30" (55.9 × 76.2 cm), courtesy of Swearingen Gallery, Louisville.

Gathering Visual Information

A SUDDEN rainstorm can crush dahlias, rip petals off roses, and in many other ways change what had been present. Obviously, it is important to record as much information as quickly as possible when you set out to paint a garden.

Bring along the right equipment. A good pair of glare-free sunglasses gives you the freedom to work in bright light. Some sunglasses change the colors you see only minimally—so that you need not worry too much about color distortion.

You'll probably want to take a portable easel and a stool. Bring along masking tape if you are working with a drawing board and sheets of watercolor paper. If the wind picks up, you can easily tape your support down more securely. Also pack an umbrella. More important, bring waterproof plastic bags to protect your works if a rainstorm suddenly threatens. You'll dry off, but your painting may not recover.

EXERCISES

Remember that strong drawing underlies all good painting. It's especially important when you need to record as much of what you see as possible. Use the following exercises to help you hone your drawing skills outside.

1. Execute a series of loose gesture drawings, getting down on paper all the major shapes that you see before you. To organize what you see, focus on one aspect—interlocking shapes, rhythmic lines, or the interplay that exists between curved and angular forms.

2. Working with a sharp pencil or pen and ink, do a detailed drawing of a garden. Capture not only the large, overall shapes, but also little details—the way flowers cluster together, the texture of the leaves, and so forth.

3. Working with color in any medium you choose, do quick studies of your subject. Try to do these at different times of day: in early morning, at noon, in midafternoon, and just before sunset. Capture how the colors change as the light changes.

4. Sketch a garden from as many points of view as possible. Which make the most interesting compositions? Which appeal to you most? Try using a viewfinder to frame what you see. Look at individual plants close up as well as in a group. Also try drawing the garden from a high vantage point—a bedroom window, or even a roof. From this point of view, you'll grasp the overall logic of what you see.

5. Sketch a garden at close range, then from a distance. Don't let the closeup sketch become too fussy or the distant study become too vague. Next, experiment with incorporating parts of both perspectives in one study. Can you highlight individual flowers while retaining the feeling of the garden as a whole?

6. Practice recording your color sensations with words. Draw a garden, then jot down color notes. Don't just say "red." That won't help you when you are back in your studio. Use descriptive terms that mean something to you— "deep red: just the color of a glass of chianti" or "spring green: the color of the plant in the living room."

7. On site, try describing the garden carefully in words. Give an account of its physical aspects and report how it affects you. Note which areas seem especially beautiful to you, which you would plant differently, and so on. This exercise forces you to think about what you are painting and to understand your reactions to your subject matter.

8. Away from your site, try drawing the garden from memory. Which parts are the easiest for you to recall, and which are the most difficult? This exercise can help you assess what visual information you need to gather. It can also make you more aware of your personal reactions to what you see.

9. Try putting together a sketch, then a painting, using portions of several different gardens. Make your works look as realistic as possible. You will be successful if the imaginary garden you create looks like it might actually exist.

10. Try to integrate architectural elements into the gardens that you draw and paint. Instead of sitting next to the house, looking out at the garden, sit outside the garden, looking at the house. How can you meld the natural and architectural forms together? How can you make the house seem like an integral part of what you see?

Drawings by Marian Appellof.

Working with Photographs

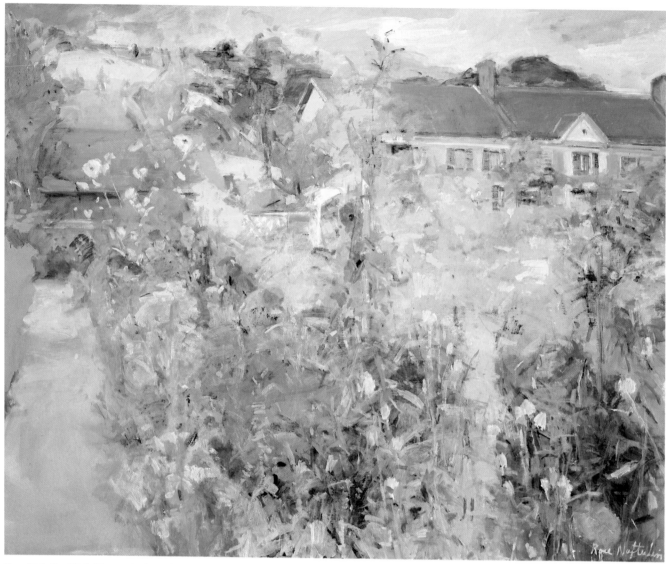

Rose Naftulin, **Pink House, Red Roofs,**
1985, oil on canvas, 40" × 50" (101.6 × 127 cm),
courtesy of Gross McCleaf Gallery, Philadelphia.

PHOTOGRAPHS can be an invaluable aid when you paint outdoors. They free you from the need to travel day after day to your site. Just as important, they allow you to paint in your studio, without all the distractions that come with painting landscapes—rain, glare, noise, curious bystanders, and so on. Photographs may make it easier to concentrate on what you are doing.

These paintings by Rose Naftulin evolved from a trip she made to Monet's gardens in Giverny, France. There she was so struck by the warm, rich color she saw that she photographed the gardens with a mind to paint them when she was back in her studio. It's important to

note that Naftulin will never paint a scene unless she has seen it first hand. She works only from her own slides and sketches done at the site.

As she paints, Naftulin refers to the projected slide, much as she would a sketch or photograph tacked to a wall. She doesn't copy the image; instead she uses the slide to help her experience again what she felt when she first encountered her subject. The adjustments that she makes as she works become clear when you compare the photographic images she used and her finished paintings, shown here and on the next two pages. The photos serve as a valuable source of information, but they have little to do with the heart of Naftulin's paintings.

You can see, for example, that Naftulin diminishes value contrast to accentuate the warm, lush color that she relishes. She also makes compositional changes. In *Pink House, Red Roofs,* for instance, she extended the left side of the scene; in *Spreading Garden,* she emphasized the daisies in the foreground to help lead the eye into the painting.

EXERCISE
Experiment with using photographs. Try shooting a garden from several different points of view, first from one angle, then from another. If possible, photograph it as the sun moves across the sky and the patterns of the shadows change. If individual flowers are especially evoca-tive, try shooting closeups of them as well.

After the photographs have been developed, use them to prod your memory, as Naftulin does, and create a painting that expresses your experience of a par-ticular scene. Then, try com-bining elements from several photographs of different gar-dens. Distill the essential in-formation from the series of pictures and make a com-posite view.

Borrow a few lessons from photography, too. Try focus-ing in on a portion of the garden and letting the rest of it blur together. A camera sees this way: when there is a short depth of field, objects in the foreground spring into focus, while those farther back become less distinct.

Rose Naftulin, **Spreading Garden,** *1985, oil on canvas, 40″ × 50″ (101.6 × 127 cm), courtesy of Gross McCleaf Gallery, Philadelphia.*

Distilling the Essence of a View

Rose Naftulin, **Mahler's Garden,**
1985, oil on canvas, 40" × 48" (101.6 × 121.9 cm),
courtesy of Gross McCleaf Gallery, Philadelphia.

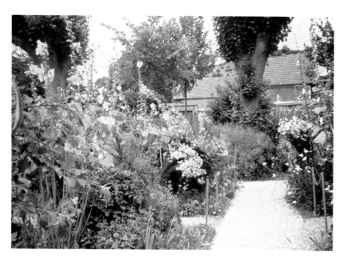

A COMPARISON of any of the photographs Naftulin works with and a finished painting shows how she distills the essence of what she sees. There is no question that her works are *painted*—they are alive with color and gestural brushwork. Naftulin's lush use of paint corresponds to the lushness of the gardens; it also gives her work a tactile, immediate feeling.

In *Mahler's Garden*, for example, the scene is quite faithfully recorded, yet the painting accentuates the excitement of the color. There are dabs of many colors, but Naftulin also clusters colors and varies the intensities to

make a few stand out clearly. In *Garden with Green Trellis*, she heightens the impact of color by broadening its area and by laying it down in loose sweeps so that it overwhelms the house. She also lessens the power of the greens, which dominate the photograph.

Naftulin likes to work on a good linen canvas with a matte oil-primed surface, because this allows her initial washes to sit on the surface, rather than soaking in (as they would on cotton canvas) or running (as they would on a slick surface). In the beginning, she mixes a large amount of medium in a jar—the medium then becomes thicker as she works. Her

palette is huge, made of glass, and filled with many colors. When she is not painting, she covers it to keep her paints pliable. As she works, she keeps several paper palettes all about her, moving to a clean palette whenever she needs one.

Naftulin begins with large turp washes, which give her the freedom to paint rapidly and to get down on canvas everything that excites her. Although the thin washes of color are incredibly beautiful, for Naftulin they are simply a starting point. As she adds thicker, denser pigment, a painting may change completely. She works all over the surface, letting the painting grow naturally.

Naftulin never knows when she starts how a painting will look at the end. She works until she feels all the problems are resolved, when nothing bothers her. Every now and then she works on just one painting. More often, though, she develops a few at the same time.

*Rose Naftulin, **Garden with Green Trellis,** 1985, oil on canvas, 44" × 52" (111.8 × 132.1 cm), courtesy of Gross McCleaf Gallery, Philadelphia.*

When she steps away from one to work on another, she is able to see the first afresh on her return.

DETAIL
Even though the paint is laid in loosely, with a flowing, gestural quality, note how

Naftulin suggests the shapes of the individual flowers. References like these make your garden paintings more believable. You don't have to get carried away with detail, though—just a few crisp strokes can summon up the feeling of all the flowers.

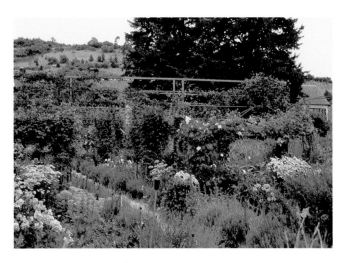

Capturing Color and Light

*I*N HER paintings of individual flowers, Carol Bolt works with carefully controlled washes of color (see page 41). When she steps outside to paint gardens, though, she works in a totally different way. Confronting a landscape, she chooses to break up what she sees into small dabs of color. Seen cumulatively, these dabs become flickering masses of color and light.

Using this kind of pointillistic technique requires some control. If everything in a painting is rendered with small bits of color that are exactly the same size, the overall texture may become too regular and too boring. To break up any potential monotony, Bolt shifts the size and even the shape of her dabs, suggesting different textures; occasionally she uses small washes of color. Sometimes she overlaps the dabs; at other times she lets bits of the white watercolor paper peek through, which increases the dazzle of the color.

In her painting *Umbrellas and Dahlias*, Bolt uses relatively flat, loose washes of bright, light-filled color to accentuate the playful shapes of the umbrellas that guard the dahlias. If she had broken their form with dabs of color, they would have seemed more weighted and lost the light, floating quality that attracted her to them when she first saw them. The dabs of darker color that surround the umbrellas and dahlias set up a strong contrast, in both value and texture. This creates a back and forth tension, as the eye focuses on the umbrellas and then shifts to the surrounding foliage.

Focus is also important in Bolt's painting *Mr. Webster's Cutting Garden*. The fore-

Carol Bolt,
Umbrellas and Dahlias,
watercolor on paper,
14" × 16" (35.6 × 40.6 cm),
collection of Mr. and Mrs. Smith.

ground is filled with brilliant yellow daffodils, yet the mass of red and violet colors is clearly the most important point of the composition. Whenever you approach a garden, try to find a similar focal point—an area that is brighter than the surrounding areas or darker in value or richer in detail. Here the dark greens in the background and the intense blue of the sky help to balance the strong reds and violets in the foreground.

DETAIL

Small shifts in value help to turn these masses of flowers into three-dimensional forms. When you look up close, there is also a surprising variety in the ways different areas are painted. The flat color of the white fence pulls it away from all the plants that surround it, while the light green foliage on the side is painted fairly wet so the color begins to bleed. The small pink flowers and daffodils in front are rendered with relatively large dabs of paint—in contrast to the red and violet flowers, which are made up of tiny dots of color. All these variations help to keep the surface of the painting alive.

EXERCISE

Do a series of studies concentrating on color, light, and value. In your first painting, concentrate on color; in the second, on light; and in the third, on value. Finally try pulling a composition together using all three.

Carol Bolt,
Mr. Webster's Cutting Garden,
watercolor on paper,
24" × 21" (61 × 53.3 cm),
collection of Dr. and Mrs. Markman.

Organizing a Myriad of Detail

A FASCINATING wealth of material awaits you in any garden. Step into one and you'll be confronted with a multiplicity of shapes, textures, colors, and even smells. Deciding what matters most to you and how to give your painting focus is a compositional challenge. If you include everything you see, your painting may seem chaotic; at the same time you may want to convey the richness of your subject. It is possible, however, to invite the viewer to examine every inch of a painting and yet give a sense of how everything fits together.

Michael Allison's intricate, detailed drawing, for example, makes you aware of every nuance, every detail of the subject. Notice, however, how Allison has massed the lights and darks, as well as the different textures, to establish diagonal rhythms that lead the eye through the picture's space. Sometimes Allison exhausts a scene in his pen-and-ink sketches; when he has finished, he finds that there is nothing left for him to accomplish in a painting.

If you delight in detail and in looking very closely at what you see, try working the way Allison does. You don't have to use pen and ink. Pencil can be just as exacting a medium. Before you start, however, look for underlying patterns and use these to organize the detail in your drawing.

Look again at Allison's drawing and notice the care he lavishes on texture. In your own drawing, experiment with different kinds of line. Make some lines squiggly and some straight; use tight cross-hatching and

Michael Allison,
Garden #2,
1979, pen and ink on paper,
18" × 23" (45.7 × 58.4 cm),
collection of Mr. and Mrs.
Gerald Siedlarczyk,
photo by Stan Crilly.

Michael Allison,
detail from: **Garden #5,**
1982, oil on canvas,
48" × 67" (121.9 × 170.2 cm),
collection of Dr. and Mrs. Joseph Glick,
photo by Jon McDowell—
for full painting, see pages 130–131.

looser parallel strokes; try making quick flecks and, if you work in pencil, vary the pressure you apply. In short, explore as many different ways as possible of creating texture with line.

Of course, you can capture just as much information in your paintings as you do in your sketches. The detail from Allison's *Garden #5* shown here reveals how much is happening in every inch that he paints (turn the page to see the full painting). When you look closely, however, you also notice that much of the detail is *suggested* rather than actual. Allison doesn't let his brushwork become too tight or too controlled. Instead, he varies the character of his strokes— from squiggles to short, choppy lines to more solid dabs of color—and in this way creates a sense of variety without using a sharp focus.

Now turn to the full painting on pages 130–131 and observe how Allison's use of color animates the painting and also gives it unity. Although there's a lot of bright color, the massing of reds and greens in particular leads the eye along different visual paths through the garden. The patches of earth, as well as the fence and light brick in the background, provide a contrast and allow the eye to rest before it moves on. To see how important these breathing spaces are, trying covering the upper right corner of the painting; without the fence and the bricks, the painting seems claustrophobic. These man-made objects suggest the world outside the garden, and open up the entire painting.

Expressing a Personal Response

ALTHOUGH he frequently paints gardens, Michael Allison doesn't consider flowers per se as his primary subject. It's not the physical properties of a particular place that he tries to capture, but rather the emotion, mood, or personality that these places seem to possess.

In his painting *Garden with Sighting Stone*, Allison tried to accentuate the strange, mysterious air that fills one garden that he knows. Long interested in the Neolithic stones that are found throughout England, Allison sculpted one from clay, then added it to the foreground to enhance the mystery of the scene. Adding elements like the sighting stone is a tricky business—unless they make sense in the context of the painting, they can easily seem theatrical.

Allison completed the study shown here while the painting was in progress. He uses color studies like this one to develop his ideas, not to record them. In this case he began with pencil, then worked up the sketch in watercolor. When the paper was dry, he went back and reworked parts of the sketch with chalk.

In the study, Allison explores the overall patterns that make up the scene. The light area around the stone becomes especially strong, since it is set off by the dark colors on the left and in the background. The light green lawn also helps move the eye backward toward the red house.

Color and brushwork play a large role in creating the eerie feeling that permeates the finished painting. Cool purples, blues, and bluish greens contrast with the warm yellow-green in the middle ground that leads to the bright red house in the rear. Loose, expressive brushwork draws attention to the stone, and its color connects with the tree in front of the house. At the same time the many different kinds of brushstrokes, suggesting different textures, direct the eye to other areas, so we inspect all the elements in the scene, as if each had a secret to reveal. Notice, too, how the change in scale from the foreground to the background and the contrast of lights and darks heighten the sense of mystery. It is as if everything were poised, waiting for a drama to occur.

EXERCISE

Paint a garden letting your brushstrokes correspond to the essence of what you see. You might use short, choppy strokes to lay in the grass, broader strokes for the sky, and fluid rhythmic strokes as you render the flowers. Keep this principle in mind: the quality of your brushstrokes is a powerful tool in getting across the tactile nature of what you are painting. Smooth, fluid strokes can suggest soft, gentle flowers; strong strokes may be better suited for more dramatic blossoms.

Michael Allison,
Study, Garden with Sighting Stone,
1984, watercolor, ink, and chalk on paper,
12"×16" (30.5×40.6 cm),
photo by Stan Crilly, courtesy of
Gross McCleaf Gallery, Philadelphia.

Right:
Michael Allison,
Garden with Sighting Stone,
1985, oil on canvas, 48"×52" (121.9×132.1 cm),
photo by Stan Crilly, courtesy of
Gross McCleaf Gallery, Philadelphia.

Combining Freedom and Control

WORKING ON a large scale, Patricia Tobacco Forrester creates realistic, yet painterly, watercolors of flowers. The larger-than-life size of the flowers makes you see them in a new way. The size also enables Forrester to handle her medium quite loosely in places while carefully controlling the overall view.

Choosing to paint flowers and other organic forms in watercolor seems natural to Forrester, because, like the things she paints, watercolor has a life of its own. Forrester loves the risk that it entails. As she explains, she isn't interested in doing "tight representational paintings" and exerting control over everything that happens. Instead, she likes to let the watercolor flow and to allow "accidents" to occur.

What fascinates Forrester is the way the paint behaves when she lays it on the paper. Sometimes she simply pushes it in the direction that it seems to want to go. The color may puddle, drying darker, or it may bleed, leaving irregular edges. All of these experiments with the paint, however, are conducted with an eye to the overall form, shape, color, and light of a particular flower. What the rushes of color do is make every flower unique.

With the large scale that Forrester uses, it is surprising that she does most of her painting outdoors, on location. Working with the paper nearly parallel to the ground, she must periodically step back to evaluate what is happening. Often, to get the size she wants, she uses two or more panels of paper. With light pencil marks, she indicates the edges of the corresponding forms so that she will know where to continue what she has begun on the first sheet of paper.

To get a sense of the scale in Forrester's works, look at the actual-size detail of *Pale Poppies* shown here. Then try to imagine the whole painting at this scale. Notice, too, how each flower is carefully defined, yet within the boundaries of that flower the paint flows freely. There is a lot of bright color, but For-rester also lets the white of the paper show through to allow the color to breathe. From the first, she tries to capture the right intensity of color. Using successive glazes would, in her opinion, lessen the immediacy of the flow of paint, which is so important to the effect she wants.

Patricia Tobacco Forrester,
Pale Poppies,
*1984, watercolor in two panels,
50" × 40" (127 × 101.6 cm),
private collection.*

Juxtaposing Flowers for Contrast

Patricia Tobacco Forrester, **Chichen-Itza: Jacknifed,** *1985, watercolor on paper, 60″ × 40″ (152.4 × 101.6 cm), private collection.*

*U*NUSUAL juxtapositions are important to Patricia Forrester—they invite the viewer to explore different levels of reality. Set against jagged, craggy trees, the flowers that she renders create a tension between the real and the unreal. In fact, both *Chichen-Itza: Jacknifed* and *Blue February* (shown in full on pages 138–139) are composites. The flowers did not appear on the trees Forrester painted, although the Chichen-Itza tree did have pinkish blossoms.

While the flowers are superimposed and jolt our expectations, they are also integrated into the painting—making their surprise believable. In *Chichen-Itza*, for example, the drama of the gnarled tree trunk is accentuated by the eccentricity of the large red and white flowers. The strong color note brought in by the flowers also punctuates the twisting movement of the branches and adds a staccato beat to the tremendous energy of the painting. Try to imagine this painting without the flowers. Although the pattern of the branches is exciting, the odd accents of the flowers heighten the overall tension.

In *Blue February*, a four-panel painting more than 6½ feet wide, the twisted trunks and branches fill our view with their nervous energy. The soft, rounded flowers that Forrester includes in the lower left corner, however, add an important contrasting note and make us reconsider what we see. There's a tension between the barrenness of the trees and the suggestion of growth and aliveness provided by the flowers and the strong green color that surrounds them.

Equally important is the tension that Forrester sets up through her handling of the watercolor medium. Both *Chichen-Itza* and *Blue February* have solid, realistic skeletons, yet the brushwork within each painting is extraordinarily loose. From a distance, the paintings are clearly realistic, but as you move in closer they become more abstract. The wonder of the paint itself and the delicate flow of color become increasingly important. This closeup view in turn affects the view of the painting as a whole—so there is a continual interplay between delicacy and hardness, soft focus and clarity, fantasy and reality.

*Patricia Tobacco Forrester, detail from: **Blue February**, 1984, watercolor in four panels, 50" × 80" (127 × 203.2 cm), private collection—for full painting, see pages 138–139.*

Biographical Notes

Michael Allison studied at the Art Institute of Pittsburgh and is now curator of the Southern Alleghenies Museum of Art in Loretto, Pennsylvania. His paintings have been included in more than twenty group and one-man shows, and he is currently affiliated with the Gross McCleaf Gallery in Philadelphia. Allison has curated many exhibitions and is a member of the Visual Arts Panel for the Pennsylvania Council of the Arts.

Carol Bolt was born in Louisville, Kentucky, and received her B.F.A. from the Chouinard California Institute of the Arts. For the past three years, Bolt has taught courses in painting flowers at the Horticultural Society of New York in New York City and at the Staten Island Botanical Garden. In 1984 she led a painting tour of Normandy and in 1985 a similar tour of southern France. Bolt's paintings have been included in seven shows. She is represented by Modern Art Consultants, the Art Collaborative, and Jane Lombard Fine Arts, all in New York City, and by Nancy Delvino in Columbus, Missouri.

Robin Eschner-Camp holds a Bachelor's degree from the University of California, Davis. Her watercolors have been widely exhibited and are included in many private collections in the United States and Europe. In 1985 Eschner-Camp's work was featured in *Painting the Still Life* by Olga Zaferatos (Watson-Guptill Publications). Currently she is represented by Allport Associates Gallery in San Francisco, Dubins Gallery in Los Angeles, and First Impressions Gallery in Carmel, California.

Patricia Tobacco Forrester received her B.F.A. and M.F.A. from Yale University; she also holds a B.A. from Smith College. She has had one-woman shows in New York City, Dallas, Pittsburgh, New Orleans, Honolulu, Washington, D.C., San Francisco, Denver, and in Storrs, Connecticut, and has participated in numerous group exhibitions. Forrester's work is in the collections of the British Museum, the Brooklyn Museum, the San Antonio Museum of Art, and many other public and private collections. She has taught at the Chicago Art Institute, Kent State University, the University of Iowa, the California College of Arts and Crafts, and Chabot Junior College in Hayward, California. Currently Forrester is represented by the Fendrick Gallery in Washington, D.C., and the Fischbach Gallery in New York City.

Pamela Glasscock was born in New Haven, Connecticut; grew up in Denver, Colorado; and now divides her time between New York City and Freestone, California. Glasscock studied at Stanford University, but the techniques she uses to render flowers evolved after graduation. She has had one-person shows at the Garden Center of Greater Cleveland (1983); the New York Academy of Sciences (1984 and 1986); the Thomasville Garden Center in Thomasville, Georgia (1985); and the Gallery Lafayette in New York City (1986). In May 1984, her watercolors were featured in *American Artist* magazine.

P. S. Gordon was born in Claremore, Oklahoma. He studied at the University of Oklahoma, then received his B.F.A. from the University of Tulsa in 1974. From 1974 to 1975, Gordon studied watercolor in the graduate school in Tulsa. In 1979 he was the recipient of a National Endowment for the Arts Grant. Gordon has had one-man shows in Tulsa, New York City, and Palm Beach, and his work has been included in many group shows. He is currently represented by the Fischbach Gallery in New York City.

Nancy Hagin was born in Elizabeth, New Jersey, and received her B.F.A. from the Carnegie-Mellon University and her M.F.A. from Yale University. She has taught at the Maryland Institute College of Art, Pratt Institute, the Rhode Island School of Design, the Fashion Institute of Technology, and Cooper Union. Hagin has received many awards—including a Fulbright Grant in 1966—and has had fourteen one-woman exhibitions. She has also participated in numerous group shows, and her works are in many public and corporate collections. Hagin is represented by the Fischbach Gallery in New York City.

Charles Le Clair has taught at the University of Alabama, Chatham College, and Temple University, where he was dean of the Tyler School of Art for many years. His work has been exhibited in numerous one-man and group shows and at the Chicago Art Institute, the Whitney and Metropolitan Museums of Art in New York City, the Brooklyn Museum of Art, and the Corcoran Gallery in Washington, D.C. Much of what he has learned as a painter has come from his work with art historians, especially Meyer Schapiro. Currently he is represented by the Charles More Gallery in Philadelphia. In 1985 Le Clair's book *The Art of Watercolor* was published by Prentice-Hall.

Gilbert Lewis attended the Pennsylvania Academy of Fine Arts in Philadelphia from 1963 to 1968. He was awarded a Cresson Memorial Prize by the Academy in 1967, enabling him to tour Europe. He received his B.F.A. from the Philadelphia College of Art in 1974 and a master's degree in creative arts in therapy from Hahnemann University of Philadelphia in 1978. Lewis's first solo exhibition was held in March 1981. More recently, in 1985, he had a a one-man show at the Noel Butcher Gallery in Philadelphia, which currently represents him. His work appears in private collections throughout the United States and England.

Nancy B. Martin lives in Glenwood Springs, Colorado, where her work has been featured in two one-woman exhibits. The first, in 1983, was held at the Oak Brush Gallery; the second, in 1985, at the Trayde Castle. Martin has studied watercolor in workshops with Stephen Quiller, Zoltan Szabo, and other well-known artists. For years she worked with batik; this, in turn, has influenced her casein paintings. Currently Martin is represented by the Kimberly Gallery in Grand Junction, Colorado.

Michael McCloskey, who currently lives in Philadelphia, received his B.F.A. and M.ED. from the Tyler School of Art in Elkins Park, Pennsylvania. His watercolors are in many private collections throughout the United States and have been featured in *American Artist* magazine. Currently McCloskey is tending an extensive collection of orchids and growing an amaryllis from seed.

Susan Sergel Monet was born in Springfield, Illinois, and has been painting flowers since she was a child. She has earned degrees in the fine arts, art history, and design. Monet maintains one studio in Shelbyville, Kentucky, and another in her home in Beverly Hills, California. She is represented by the Wakefield Scearce Galleries in Shelbyville, by Lynn Kari Petrich in New York City, by Monet Fine Arts in Beverly Hills, and by Tryon and Moorland Gallery in London.

Rose Naftulin was born in Philadelphia and studied at the Graphic Sketch Club, the Philadelphia College of Art, the Barnes Foundation, and the Cheltenham Art Center. Over the past twenty-five years, she has had eight one-woman shows and her work has been included in numerous group exhibitions. Her paintings have been shown at the Philadelphia Museum of Art, the National Academy of Design, and the National Arts Club, and appear in the collections of the Woodmere Art Museum in Philadelphia and the main branch of the Philadelphia Library. Naftulin is represented by the Gross McCleaf Gallery in Philadelphia.

Elizabeth Osborne was born in Philadelphia and studied at the University of Pennsylvania, where she earned her B.F.A., and at the Pennsylvania Academy of Fine Arts. She has received many awards and fellowships, among them a Fulbright and a Ford Foundation Purchase Prize. Osborne's works have been included in countless group shows; she has had thirteen one-woman shows. She also appears in many public collections, including those of the Pennsylvania Academy of Fine Arts and the Philadelphia Museum of Art. Osborne is represented by the Fischbach Gallery in New York City and by the Marian Locks Gallery in Philadelphia.

Kathleen Pawley has lived in Louisville, Kentucky, since she was a child. In 1985 her work was included in the American Artist Magazine National Art Competition exhibition at the Grand Central Art Galleries in New York City. She has also participated in many shows in Kentucky. Pawley studied at Jefferson Community College in Louisville, at the Louisville School of Art, and in numerous workshops. She

is currently represented by the Swearingen Gallery in Louisville and is an Artists Member of the Kentucky Watercolor Society.

Susan McKinnon Rasmussen, N.W.S., received her B.A. degree from Oregon State University in 1971. She resides and maintains a studio in Portland and has conducted watercolor workshops throughout Oregon. Rasmussen is a juried active member of several watercolor societies, including the National Watercolor Society, Watercolor West, and the Watercolor Society of Oregon, of which she is president. An award-winning artist, she has exhibited in many national juried shows and is currently represented by the Lawrence Gallery, located in Portland, Sheridan, and Salishan, Oregon.

Karen Segal received a B.S. degree from the Philadelphia College of Art. Since 1963 she has taught in various institutions; at present she conducts private lessons in her studio in Philadelphia. Segal's paintings have been included in three group shows at the Gross McCleaf Gallery in Philadelphia, and she has had a solo exhibition at the Hahnemann University Gallery in Philadelphia.

Jean Shadrach makes her home in Anchorage, Alaska. She began painting in 1956 at the University of New Mexico, then continued her studies in workshops and at the University of Alaska Methodist University and Anchorage Community College. Her work is in several corporate collections and has appeared in juried art exhibits from Georgia to Alaska. Shadrach was the first woman to be invited to give a one-person show at the Anchorage Historical and Fine Arts Museum, and the Frye Museum in Seattle presented a retrospective of her work in 1985. She is represented by Artique in Anchorage; Old Town Gallery

in Park City, Utah; and House of Wood in Fairbanks, Alaska.

Harriet Shorr is a native New Yorker. She received her B.A. from Swarthmore College and her B.F.A. from Yale University. Currently she teaches at the State University of New York at Purchase; in the past she has taught at Swarthmore College and the University of Pennsylvania. Shorr has had twelve one-woman exhibitions and numerous group shows. Her work is included in many corporate and private collections. The Fischbach Gallery in New York City represents Shorr.

Mary Jane Spring holds a B.F.A. with a specialization in scientific illustration. Since 1977, she has been the scientific illustrator at the University of Connecticut in Storrs. Spring specializes in full-color taxonomic plates of plants and enjoys doing watercolors of native wildflowers. Her works have been published in numerous scientific journals, in the *American Orchid Society Bulletin*, and in several Audubon Society field guides.

John Thornton received a B.A. in mathematics from the University of North Carolina in 1974, then studied painting at the Pennsylvania Academy of Fine Arts. He is the recipient of many awards, including a Lewis B. Ware Traveling Scholarship in 1980. Since 1984, Thornton has worked as an instructor of painting and art history at the Art Institute of Philadelphia. He is currently represented by the Rodger LaPelle Gallery in Philadelphia.

Jim Touchton was born in Georgia. He earned his B.F.A. degree from Valdosta State College, University of Georgia Studies Abroad, in Florence, Italy, and his M.F.A. from the University of Georgia in conjunction with the New York Studio School in Paris. His paintings are in

many corporate and private collections, and in the past ten years he has had five one-man shows and participated in many group shows. The Fischbach Gallery in New York City represents Touchton.

Susan Headley Van Campen attended the Moore College of Art and the Pennsylvania Academy of Fine Arts. She is the recipient of the 1973 Cresson Memorial Traveling Scholarship from the Pennsylvania Academy and the 1983 Marsha Moss/Rose Graff Award from the Cheltenham Art Center. Van Campen's works appear in the collections of the Delaware Art Museum and Rutgers University, as well as many private and corporate collections. She has had one-woman shows throughout the United States, most recently at the Gross McCleaf Gallery in Philadelphia, the Maine Coast Artists Gallery in Rockport, and the Allport Associates Gallery in San Francisco. Her watercolors are included in *Painting the Still Life* by Olga Zaferatos (Watson-Guptill Publications, 1985).

Eleanor Wunderlich was taught drawing and watercolor by her father, the late Courtenay Brandreth, a naturalist and painter of wildlife. A graduate of the Parsons School of Design in New York City, Wunderlich also attended the Art Students League, where she studied watercolor. To master botanical illustration, she attended classes at the Kitchawan Research Station of the Brooklyn Botanic Garden and at the New York Botanical Garden, where she now teaches botanical illustration. In 1983 the New York Horticultural Society mounted a one-woman exhibition of Wunderlich's work. She is represented by the Images Gallery in Briarcliff Manor, New York.

Index

Elizabeth Leonard's *Painting Flowers* is a wonderful source of inspiration for artists at all levels. Filled with striking illustrations by contemporary artists, it offers painting ideas and exercises that encourage fresh, original approaches to portraying flowers. The painting styles are diverse, with masterfully executed pieces in watercolor, oil, acrylic, gouache, casein, and pastel.

The book begins with an exploration of the practical aspects of working with flowers. There are tips on how to care for flowers and make them last as long as possible, plus advice on how to arrange flowers to create the effects you want. Included, too, is an informative discussion of plant anatomy and botanical illustration. A dozen drawing exercises open up new ways of looking at flowers—with an artist's eye.

Color is unquestionably one of the most intriguing aspects of painting flowers, and Elizabeth Leonard reveals a variety of ways of using color to create exciting artwork. She shows you how to use value, intensity, and temperature to enhance your flower paintings and how to develop lively color interactions. Her concrete, easy-to-follow assignments encourage you to explore your palette and to discover different ways of mixing color as you paint.

Turning to composition, the author offers illuminating insights into effective design. You'll learn what makes different paintings work and how to apply this knowledge to your own flower paintings. There is advice on selecting a horizontal or vertical format, choosing an unusual viewpoint, and balancing flowers with surrounding space. Thought-provoking exercises challenge you to expand your ideas about composition.

Beyond the painting of flowers themselves is the role of flowers in still lifes. By combining flowers with objects, you can evoke a particular mood, hint at an underlying story, create dynamic contrasts, or capture the magic of the everyday. Each of the still life paintings included in this book suggests a different approach, and there is abundant information to guide you in arranging setups that are fascinating to paint.

As you move outdoors, to the depiction of gardens, you'll encounter another realm of painting possibilities. Elizabeth Leonard provides invaluable tips on the equipment you'll need and on how to gather visual information through sketches and photographs so you can continue a painting in your studio. Again, the paintings in this section will spark your own creativity.

This book is definitely a "must" for anyone who wants to paint flowers. Both beginning painters and accomplished artists will be stimulated by the stunning illustrations and insightful text. Especially delightful, and helpful, are the exercises that are liberally scattered throughout the book.

ELIZABETH LEONARD is an art historian who lives in New York. She has written and edited numerous articles, essays, and books.

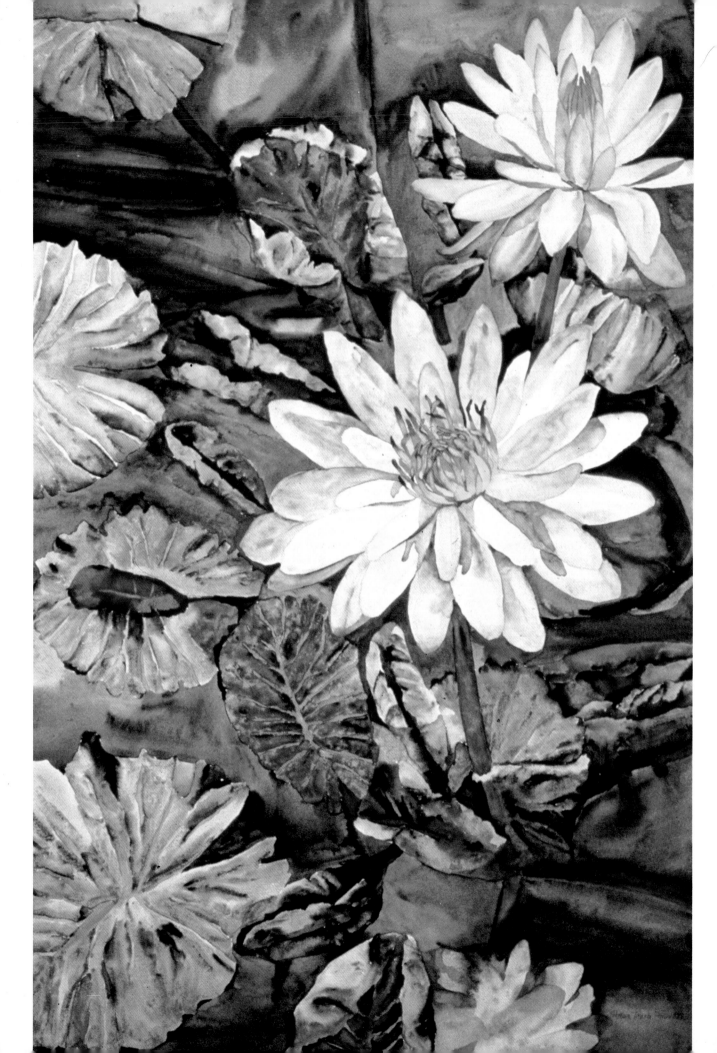